16

CUBISM

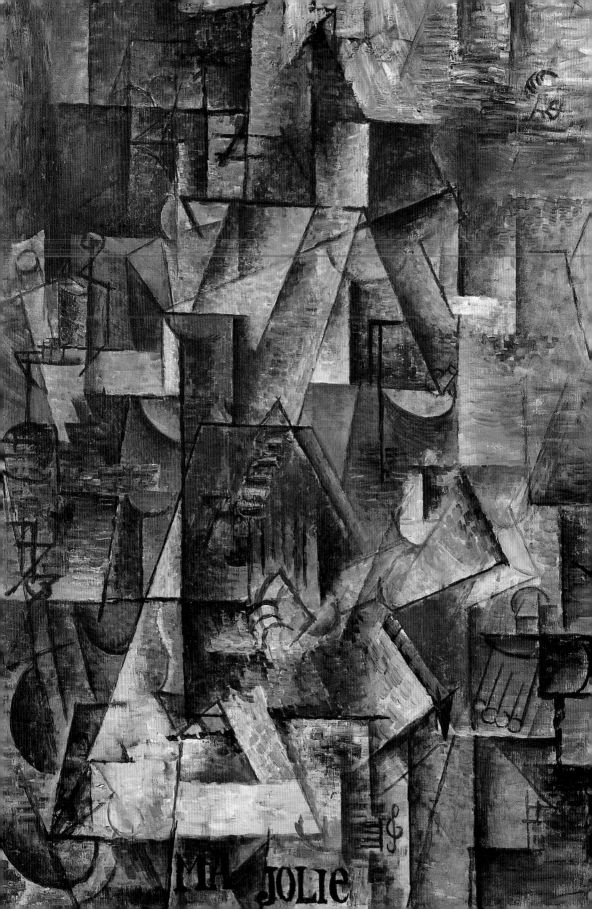

CUBISM

David Cottington

TATE GALLERY PUBLISHING

Cover:
Robert Delaunay,
Windows Open
Simultaneously
(First Part, Third Motif),
1912 (detail of fig.49)

Frontispiece:
Pablo Picasso,
'Ma Jolie' (Woman with
Zither or Guitar),
1911–12
(detail of fig.55)

ISBN 1 85437 251 3

A catalogue record
for this book is
available from the
British Library

Published by order
of the Trustees of the
Tate Gallery
by Tate Gallery
Publishing Ltd
Millbank, London
SW1P 4RG

First published 1998
Reprinted 2001
© Tate Gallery 1998,
2001

Cover designed by
Slatter-Anderson,
London.
Book designed by
Isambard Thomas

Printed in Hong
Kong by South Sea
International
Press Ltd

Measurements
are given in
centimetres,
height before width,
followed by inches
in brackets

Contents

INTRODUCTION: MODERN TIMES

The decade before the First World War was an extraordinary period in the history of Paris. Newly refurbished by the massive programme of urban development launched by Baron Haussmann half a century earlier, the city's reputation as the capital of luxury and entertainment was at its height, sealed by the *Exposition Universelle* in 1900, which had drawn fifty million visitors, by the rapid expansion of its department stores and the proliferation of its theatres, music-halls and cinemas. Yet beneath the glittering facade of this *belle époque* spectacle, Parisian society – like France itself – was riven by conflicts and contradictions. The dynamic of capitalism that was driving its booming economy exacerbated already sharp social inequalities, and met with mounting resistance from working class men, organised in the new movements of Socialism and syndicalism (or trade unionism), and from women in the increasingly vociferous feminist movement. The rapid growth of the city itself, and of its new forms of mass transportation, consumption and entertainment, threatened existing, often rural, industries and ways of life to which there remained deep attachment. Meanwhile international competition for colonial possessions and markets fuelled a spirit of nationalism which, ignited by clashes with Germany over its Moroccan protectorate in 1905 and again in 1911, led inexorably to the conflagration of 1914.

Within this complex and dynamic society developed the diverse community of the artistic avant-garde. Drawn to Paris by its cultural prestige, young aspirant artists from across Europe made this the largest,

most diversified and most influential artistic community of all those that flourished in the early years of this century. This was the context of the emergence and development of Cubism, perhaps the seminal movement for the history of Modernism in all the arts, and certainly one of the most complex and contradictory of the many 'isms' that it spawned. It was initiated between 1907 and 1910 within two quite distinct milieux of the avant-garde – on the one hand that of Pablo Picasso and Georges Braque, centred on the studios of Montmartre and the art dealers who frequented them, and on the other the left-bank circle of Albert Gleizes, Jean Metzinger, Fernand Léger, Henri Le Fauconnier and Sonia and Robert Delaunay, oriented towards the annual exhibitions of the Salon d'Automne and the Salon des Indépendants. This pioneering phase of Cubism as a style and a movement, however, was brought to an end by the war. That summer of 1914, Picasso was painting with Braque and André Derain in the south of France, and took his friends to Avignon station at the beginning of August to join their regiments; 'I never saw them again', he said. In fact he did, many times, but by this he meant that their relationship was never to be the same; the Cubist adventure was over.

Yet it had been approaching its end, as an adventure, for some months, as the style and the movement diversified through the work of increasing numbers of adherents, and as its originators began to go their separate ways. Already, in the autumn of 1913, the critic Roger Allard had noted the disappearance of an identifiable group style, and declared the dismemberment of 'the Cubist empire' to be 'a *fait accompli*'. The outbreak of war both confirmed this dismemberment, as military duties claimed some of Cubism's key players, and ushered in a decade of consolidation, and contestation, of its achievement.

Two works made in the spring of 1914 summarise between them much of that achievement and indicate the diversity of the concerns that the Cubist movement subsumed over the previous five years. One of them, by Robert Delaunay, a former leading member of what we can call the 'salon' Cubist group, was public in its address – if not large, still big enough to hold its own in a crowded exhibition hall, with a recognisable and contemporary, indeed topical, subject matter and an attention-grabbing motif. The other, by Picasso, the principal 'gallery' Cubist, was correspondingly private in scale and self-effacing, even humble, in appearance, its putative spectator one of the small group of clients and friends who visited the artist's studio or the premises of his dealer. Together they also suggest – in very different ways – how this arcane avant-garde style was anchored in the political, economic and social dynamic of pre-1914 Paris.

The subject of Delaunay's painting *Political Drama* (fig.1) was a recent and spectacular scandal: the shooting dead in his office, on 16 March 1914, of the editor of the leading conservative newspaper *Le Figaro*, Gaston Calmette, by the wife of Finance Minister Joseph Caillaux. Calmette had for some days been conducting a campaign to discredit the politician, and was threatening to publish some of his early love-letters to a former mistress. This was no straightforward *crime passionnel*, however, for the reasons for Calmette's

animosity were profoundly political, and his campaign was, it is thought, orchestrated by President Poincaré himself. The first of his motives was Caillaux's opposition to the extension of conscription for military service from two years to three, a measure of preparedness for possible war which, in the wake of the second clash with Germany over Morocco in 1911, became for the growing nationalist majority something of a litmus test of patriotism. Caillaux's campaign against the Three Years Law in the months leading up to its enactment in August 1913 aligned him with the antimilitarism of the Socialists and syndicalists, and against the rest of the republic. On top of this, he was proposing to introduce an income tax, the idea of which was anathema to the middle class, at a moment when political militancy on the left was leading many in that class to fear a revolutionary upheaval. To the opinion-formers of the Third Republic such as Calmette – and even its President – he was clearly a liability.

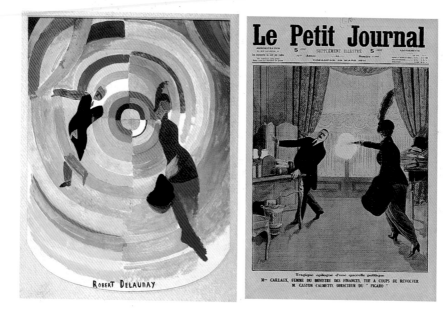

1
Robert Delaunay

Political Drama 1914

Oil and collage on cardboard
88.7 × 67.3 (35 × 26)
National Gallery of Art, Washington. Gift of Joseph H. Hazen Foundation, Inc.

2
Front cover, *Le Petit Journal*, 29 March 1914

Bibliothèque Nationale de France

Delaunay's subject therefore brought together two of the salient political issues of that decade: nationalism and class conflict. It also suggested a third, for Mme Caillaux's action in defence of her husband could not have been without significance for what was termed 'the woman question' at a moment of increasingly vocal demands by women for political and social equality. Not that he chose it directly for these reasons: it appears, rather, that he was struck by a newspaper artist's 'impression' of the incident that was published some days later (fig.2), in which Mme Caillaux's attack was pictured against a window, her pistol-shot creating an aureole of light. This happened to be the very motif that Delaunay had been exploring in his recent paintings, as he experimented with the constructive and symbolic potential of spectral colours arranged in relationships of complementary pairings. In *Political Drama*, based clearly on this illustration, he turned the aureole into an implicit target that expands to fill the picture surface in

concentric, quartered circles of bright colour – a pattern almost identical to that of another work he made around this time, the extraordinary *First Disc* (fig.3), which has some claim to be counted among the first-ever abstract paintings. Works like the latter were at the leading edge of artistic innovation in 1914, and as such were almost certainly incomprehensible to the salon-going public; as his letters of the time reveal, Delaunay was keenly aware of this fact. His choice of such a notorious incident as Calmette's assassination was, it seems, not fortuitous but deliberate, an attempt – in keeping with other works made by Delaunay and his wife Sonia before 1914

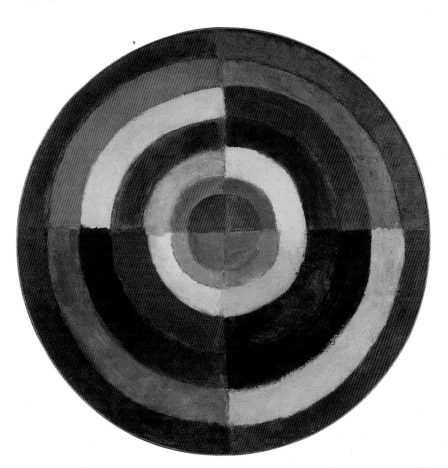

3
Robert Delaunay

First Disc 1914

Oil on canvas
134 (52¾) diameter
Private Collection

– to use a popular subject as a vehicle for his pictorial innovations so as to make the latter accessible to a public beyond that of the avant-garde community. The problems raised by such a combination of esoteric experimentation and public address we shall explore later, but it is significant that such an attempt should have been made at a moment when the new technologies of newspaper photography and newsreel film were taking over from painting and illustration the role of documenting historic events, and were dictating the terms of visual representation of public life. The response of most avant-garde artists to this development seemed to be to turn from such issues to questions of form and colour for their own sake,

yet *Political Drama* can be seen as an ambitious attempt, from within the most aesthetically radical avant-garde movement, to challenge it, by both reasserting painting's public role and modernising its means of communication.

If Delaunay's picture suggests lofty ambitions for Cubism, Picasso's *Still Life* construction (fig.4), made in that same spring, suggests the opposite. Its collection of humble materials – some scraps of wood and tasselled braiding, painted and arranged to look like a slice of bread and sausage, a knife and a wine glass on a café table beside a wall – implies a rejection not only of the traditional materials of art but of all that Delaunay was claiming on its behalf. Yet, in its way, this little work embodies quite as fundamental an engagement with questions of the representation of modern life, and the role of art within it, as *Political Drama*. Its materials are not only those common to everyday objects, they also jut out into the space of the spectator. Through their likeness to such objects they at once create a fictive space – that of a café table – and call it into question by their sheer physicality and by dispensing with the usual mediating devices of frame and pedestal. At the same time, likeness itself is called into question: for if the bread, sausage slices and knife look real, the glass has something of the character of a diagram, its transparency and volume implied by the wooden arc of its lip, at right angles to its elevation; while the table-top slopes downwards, as if seen from above, and parts company with the glass that is supposedly standing on it.

In thus combining different conventions of representation, Picasso points to their conventional character. Indeed he does more: for while the spectator may not be fooled by the bread and sausage, which are identifiably made of wood, the braid *is* braid, of just the kind that edged many a tablecloth in 1914; thus the border between fiction and reality – between what is art and what is not – is also compromised. Moreover, the status of the object as art is guaranteed neither by the materials themselves nor by any evidence of skill (at least, of any traditional artistic kind) in its fabrication; instead, the pathos of the poverty of the former and rudimentary character of the latter are offset, even highlighted, by the wit of their juxtaposition. It is the inventiveness with which Picasso has both conjured this fictive scene out of so little and at the same time revealed the artifice of art, that gives the work its charm; it is as if the artist has transformed the dross of these cast-off materials into the gold of art through the alchemy of his creative imagination.

Such alchemy drew, in 1914, upon features of a modern commercial culture that was rapidly growing and diversifying as new methods of mechanised production met burgeoning demand for consumer goods. The braid tassels in particular were an imitation of materials and techniques that belonged to a pre-industrial, luxury craft tradition, appropriated for more vulgar use as mass-production brought their price within reach of the majority. Their deployment here, to designate a table of fake food against a wall with real but conventionally illusionistic *trompe-l'oeil* moulding, was in keeping with the masquerade of materials that characterised modern décor.

4
Pablo Picasso
Still Life 1914
Painted wood and upholstery fringe
$25.4 \times 45.7 \times 9.2$
($10 \times 18 \times 3\frac{1}{2}$)
Tate Gallery

But such components of Picasso's construction were distanced from their origin by the play of ambiguity and irony around which the wit of the *Still Life* turns. He juxtaposes 'real' tablecloth against *trompe-l'oeil* bread and a glass drawn in short-hand, in a Cubist code that refers this work back to the series of paintings, collages and constructions through which it had been elaborated over the previous two years. If the adoption of the cast-offs of a degraded commercial culture was for Picasso a means of subverting the conventions of academic art, this private game of wit and inter-reference enabled this *Still Life* to resist absorption by that commercial culture, to maintain, against its burgeoning pressure, a space for reflective and critical art.

In truth both Picasso and Delaunay had moved, with these two works, some way from Cubism's original starting-points and initial frame of reference. Delaunay had publicly distanced himself from the salon Cubist group eighteen months earlier, and *Political Drama* exhibits neither the

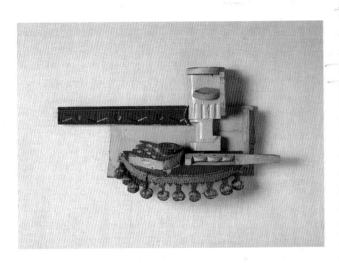

juxtaposition of different viewpoints nor the fragmentation of forms that have come to be seen as the hallmarks of the Cubist style. If these qualities are residually present in Picasso's construction – in the diagrammatic glass and the slope of the table – his conjuring with scrap materials in three dimensions opened up implications for sculpture that, as we shall see, called Cubism's own premises into question. Yet neither work would have been possible without the collective experience of the Cubist movement. In their combination of the popular and the esoteric, in their foregrounding of the devices of illusionism – Delaunay via his somewhat programmatic demonstration of the constructive role of colour, Picasso through his game of make-believe – these artists draw, if in radically different ways, on ideas and pictorial practices that had been consolidated over six or seven years of shared experimentation, as the following chapters will show. Fundamental to that experimentation was awareness of the conventional character of visual representation – a recognition that painting did not imitate the visual world, but represented it through conventions and devices, such as perspective and modelling, in ways analogous to language, and that it could only be modern if this linguistic character were explicitly acknowledged. Like the words of a language however, what such conventions and devices meant depended on their accent or inflection, and 'modernity' was a word painted (and sculpted) in many different accents within the Cubist movement, as we shall discover.

I

5
Pablo Picasso

*Les Demoiselles
d'Avignon* 1907

Oil on canvas
96 × 92
(243.9 × 233.7)
The Museum of Modern
Art, New York. Acquired
through the Lillie
P. Bliss Bequest

AVANT-GARDE AND AVANT-GUERRE

Little in their previous acquaintance either with Picasso's painting or that of other aesthetically radical artists in Paris in 1907 could have prepared those who viewed *Les Demoiselles d'Avignon* that year for the experience (fig.5). It was a shockingly unconventional work, its quintet of brazen, naked whores – two of them monstrously deformed and two others implacably unblinking – lined up to confront the spectator across a claustrophobically flattened, angular space. Even after almost a century, this picture remains unsettling both in its raw sexuality and in the violence it does to conventions of spatial illusion, figural integrity and compositional unity. Although it was not exhibited publicly for almost another decade, the painting gained immediate notoriety in the artistic community of Montmartre – a fact suggesting that a *tour de force* of some kind was already anticipated from a young Spaniard whose prodigious talent was obvious, and whose reputation was rapidly growing in the milieux of those who were making and collecting new art. That Picasso should have met that expectation, however, with a painting that appeared to turn its back on that talent, to go out of its way to look horrid, was itself as unexpected as the work's appearance. His dealer Daniel-Henry Kahnweiler later recalled that, to everyone who saw it, the painting seemed 'something mad or monstrous', while the artist's friend Gertrude Stein reported that the collector Sergei Shchukin had almost been reduced to tears by the loss for French [sic] art.

Picasso's motivation for painting such a shocking picture appears to have come not only from an appetite for iconoclasm and a profound sense of his

own artistic ability – qualities that have come to be associated with his very name – but also from an attitude that was substantially a product of that pre-First World War decade: avant-gardism. A spirit of rebellion against academic convention and bourgeois taste had characterised a strand of artistic practice in Paris since early in the nineteenth century. From the

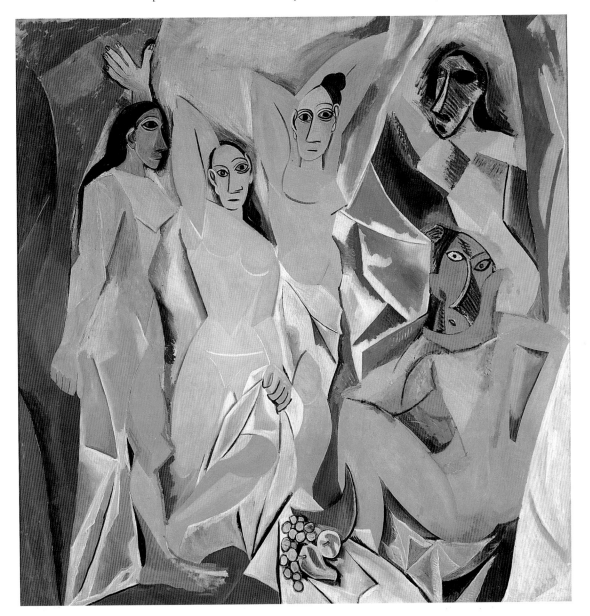

individualism and technical brio of the Romantics such as Eugène Delacroix, through the ironic and oblique observations of Edouard Manet on modern city life and painting's relation to it, to the utopian visions of Vincent van Gogh's sun-drenched Provence and Paul Gauguin's Tahitian paradise, artists had engaged with and represented on canvas a deepening

culture of alienation from the social, moral and aesthetic conventions of modern capitalist society. In the last years of the nineteenth century that alienation both became more acute and found institutional support. Increasing numbers of aspirant artists and writers, flocking with stars in their eyes to Paris as the cultural capital of Europe, found their paths to a glittering career – the state art schools, the juried salon exhibitions and their hierarchy of prizes, the established newspapers and literary magazines – choked by overcrowding and obstructed by hidebound protocols. In response, they turned increasingly to alternatives, exhibiting together in informal groupings, networking between their multiplying café-based milieux to promote, compare and contest new ideas and practices, which they wrote about in ephemeral little magazines, and discovering a small but slowly growing number of private art dealers and collectors willing to risk investment in their work. From the Impressionists' exhibitions of the 1870s and 1880s, through the foundation of the unjuried Salon des Artistes Indépendants in 1884, to the pioneering dealerships of Paul Durand-Ruel, Ambroise Vollard and the brothers Bernheim-Jeune, this alternative infrastructure steadily expanded.

It was not until after the turn of the century, however, that this unofficial artistic population became the counter-cultural community of the avant-garde – or more properly avant-gardes, since by now it numbered thousands of artists and writers; one critic estimated in 1911 that nearly 30,000 new paintings would be shown in Paris that year, while nearly 200 small literary and artistic magazines, each declaring and promoting a different 'ism', were founded between 1900 and 1914. Such numbers were themselves a reason for this consolidation; another was the widening of its market base, as more dealers and collectors began to speculate in new and unorthodox art. In 1904 the Société de la Peau de l'Ours (Skin of the Bear Society), was founded expressly to invest in such art and then sell it after ten years. The Society's name came from La Fontaine's fable in which two hunters sold the skin of a bear before they had even tried – and failed – to catch the animal. (Unlike these unfortunates, the Society realised a handsome profit from the sale of its collection in 1914.) By 1909, indeed, the contemporary art market was buoyant enough to support a new kind of art dealer. Opening his gallery in 1907, Kahnweiler began two years later to narrow his purchases to the work of only four or five artists, and in particular that of two – Braque and Picasso. From the spring of 1909 he undertook to buy almost everything they produced – a move that was at once a major gamble and a vote of confidence in the extraordinary Cubist pictures they were beginning to paint.

A third factor was the growth in Paris of consumerism, at the centre of which were the rapidly expanding department stores, and with it the emergence of modern marketing techniques. Newspapers gave steadily greater space to advertisements, billboards appeared all over both the city and the surrounding countryside, and people across France, as elsewhere, were bombarded with promotional hyperbole in all media. The appearance of Italian poet Filippo Tommaso Marinetti's 'Founding Manifesto of

Futurism' on the front page of *Le Figaro* in February 1909 signalled the appropriation by artists of such techniques, for which a critic – inevitably – coined the generic term 'Futurist publicity'. From around this time, the salon and gallery publics of Paris became accustomed to the presentation of new art as if it were another form of novelty commodity, as artists without dealers and writers without publishers resorted to the proclamation of manifestos and movements, and the founding of magazines as the means of elbowing their way to the front of the race for a reputation.

A fourth factor was a change in the political temper of the French Third Republic. The new century had opened on a spirit of collaboration between liberal intellectuals and artists, on the one hand, and the political left, including the organised working class, on the other. It was founded on – and symbolised by – the 'Bloc des Gauches', a coalition between Socialist and Radical parties that gave the centre-left a working majority in parliament. Its reach went beyond government, however, into the cultural arena, fostering both a belief in the progressive social purpose of art, and a range of initiatives through which this purpose was promoted: art study groups, evening class institutes and the like. When the Bloc collapsed in 1905–6 under the pressures of mounting nationalism in response to the 1905 Moroccan crisis, and working-class protest at the ineffectiveness of parliamentary Socialism, much of this inter-class collaboration came to an end. As the politically organised working class withdrew behind the stockade of trade unionism, their former intellectual and artist comrades reciprocated, exchanging aesthetic for social militancy and promoting artistic elitism in place of political solidarity.

The term 'avant-garde' appears to have been first applied at this time to – and by – aesthetic groupings seeking to distinguish themselves from more orthodox artists and styles. On one level it was a badge of membership, expressing a sense of collective identity on the part of artists alienated and marginalised by mainstream society and/or its dominant cultural institutions, and, for many, expressing a commitment to aesthetic renewal that replaced their former social activism. On another it stood for the panoply of self-promotional strategies and devices that helped to distinguish an artist or aesthetic innovation from the many others in the marketplace. On a third, it represented a common commitment to the idea of progress in art, the belief that only new aesthetic ideas and practices were adequate to the representation of the experience of modernity. On all of these levels it was a significant factor in the emergence and subsequent history of Cubism.

Thus the *Demoiselles d'Avignon* was the result of, among other things, a deeply felt commitment on Picasso's part to the overhaul of painting's formal conventions and the enhancement of its expressive potential. He took his cue in this partly from Cézanne's efforts to fashion a way of painting that would lay bare – or at least open up for exploration by the viewer – the complex process of pictorial representation. Especially important in this respect was Cézanne's extended series of paintings of female bathers in which relationships of colour and line, figure and ground,

mass and plane are so orchestrated as to emphasise both the timeless monumentality of their massive nudes and the means of their pictorial construction (fig.6). Painted in the year after Cézanne's death and at a moment when the latter's reputation – secured by a big retrospective exhibition at that year's Salon d'Automne – was greater than ever, Picasso's picture was, characteristically, less a homage to the 'master of Aix' than a challenge. The abrupt changes in the manner of depiction of the five nudes, and the violent distortion (and contortion) of the squatting figure at the lower right, in particular, were both an acknowledgement and a critique of Cézanne's painstaking efforts to reconcile the juxtaposition, in a single painting, of different perspective schemas with the requirements of verisimilitude and pictorial harmony. Although apparently a direct quotation from the seated figure in Cézanne's *Three Bathers* (fig.7), this squatting nude entirely disregards both requirements, and the in-your-face quality of her stare provided the most disconcerting confrontation for the

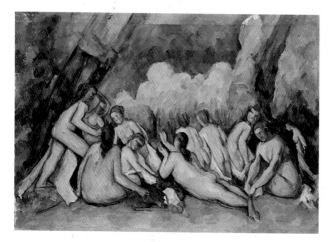
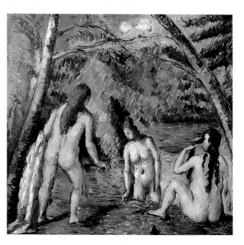

viewer since Manet's *Olympia* over forty years earlier.

There were other more immediate rivalries, however, than that with Cézanne, or indeed Manet. At the 1907 Salon des Indépendants Henri Matisse exhibited his *Blue Nude ('Souvenir de Biskra')* and Derain a *Bathers* work, both painted earlier that year (figs.8, 9). Plainly related to Cézanne's great figure compositions – Matisse at that time owned the *Three Bathers* – these two works also represented a striking development beyond the classical frame of reference of the latter, in drawing on the example of non-European, and in particular African, cultural models. They did so not only explicitly in the case of Matisse (Biskra was then a military outpost and nascent tourist oasis in sub-Saharan Algeria, which he had visited the previous year) but also implicitly. Though the figures of both paintings were posed in a manner reminiscent of classical sculpture (and, in the *Blue Nude*, redolent of the central figure in Matisse's own idyllic *Bonheur de Vivre* of 1905–6), their physical features clearly connoted 'Africanness'. For Europeans such as Matisse and Derain – and Picasso – this quality stood

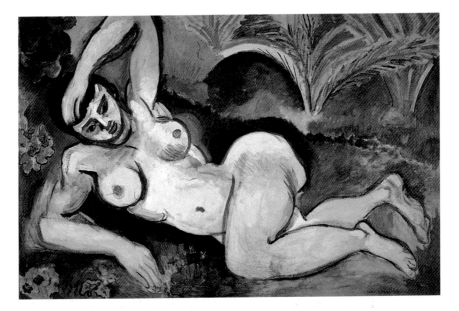

6 *far left*
Paul Cézanne

Bathers 1898–1905

Oil on canvas
127.2 × 196.1
(50⅛ × 77⅛)
National Gallery,
London

7 *left*
Paul Cézanne

Three Bathers
1879–82

Oil on canvas
52 × 55 (20½ × 21½)
Musée du Petit Palais
de la Ville de Paris

8
Henri Matisse

*Blue Nude ('Souvenir
de Biskra')* 1907

Oil on canvas
92.1 × 140.4
(36¼ × 55½)
The Baltimore Museum
of Art. The Cone
Collection, formed by
Dr Claribel Cone and
Miss Etta Cone of
Baltimore, Maryland

9
André Derain

Bathers 1907

Oil on canvas
132.1 × 195
(52 × 76¾)
The Museum of Modern
Art, New York. William
S. Paley and Abby
Aldrich Rockefeller
Funds

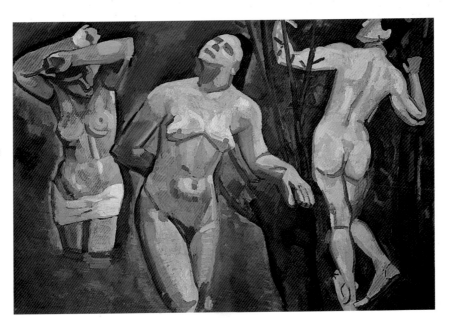

for an 'otherness' that they at once embraced and feared.

Like Gauguin and the *Japonistes* a generation earlier, artists of this emergent avant-garde sought to pioneer a new aesthetic vision by looking far beyond Europe for examples of pictorial and sculptural representation that would endorse their own dissatisfaction with the empty virtuosities of academic Naturalism or sentimentalised Impressionism that dominated the salons. Artifacts from central and west Africa were flooding into the ethnographic museums of Europe (spoils of the unseemly and often brutal scramble for imperial possession of territories such as Dahomey and the Congo basin) (fig.10). They appeared enticingly exotic and primitive from a dominant colonialist and racist perspective that viewed non-western societies as both Europe's opposite and Europe's childhood: undisciplined by reason and scientific understanding, in thrall to superstitions and to an unconstrained sexuality that western civilisation had learned to master. If such mastery and rationality were the marks of Europe's superiority, they also had their limitations, and in the decade before 1914, non-western culture – and in particular, 'orientalism' – was for fashionable Parisians a sign for hedonistic but dangerous excess. The main vehicles for their fantasies were the sumptuous spectacles of Sergei Diaghilev's Ballets Russes such as *Cleopatra* (1909) and *Schéhérazade* (1910). Black, or sub-Saharan, Africa was distinct in crucial respects, however. Unlike the countries whose cultures fuelled the myth of orientalism, it was as yet unassimilated into the French – or indeed European – colonial framework, and tales of depravity and outlandish customs among Africans, brought back by those engaged in their subjugation in the name of France (or Belgium, or England) served both to reinforce a stereotype of black peoples as savages – and thus justify that subjugation – and yet to heighten European fascination with the 'dark continent'.

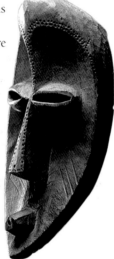

As the paintings by Matisse and Derain suggest, this fascination had a strongly sexual element – for male Europeans that is: Africa's 'otherness', for all its 'savage' quality, was – like orientalism – characteristically female and erotically charged. The left-wing satirical magazine *L'Assiette au Beurre* made this plain in the year that *Blue Nude* was painted, remarking with withering innuendo that the recent brutal conquest of Morocco and the proliferation of brothels that followed it showed that 'the principles of Peaceful Penetration and the Open Door' were strictly observed by French colonialists. In this context Matisse's achievement in his souvenir painting was thus, on the one hand, to give Africanist fantasy an aesthetic legitimacy, and on the other to spice up the weary theme of the *odalisque* with the dangerous exoticism of 'Africanness'.

Les Demoiselles d'Avignon was, among other things, Picasso's riposte to both achievements. He had known of Matisse since the controversial launch of Fauvism at the 1905 Salon d'Automne, and encountered him warily at

Gertrude Stein's the following year; mutual recognition of their very different abilities immediately created a sharp if grudging rivalry, and from that point on they maintained an obsessive interest in each other's painting. Already embarked on the *Demoiselles* project (which, as the unprecedented number of preliminary studies indicates, was by far his most ambitious work to date), Picasso took Matisse's picture as a provocation, not only in its stylistic boldness, but also in its open reference to 'Africa' – and, perhaps just as importantly in the context of self-promotional avant-gardism, because of the outcry it caused on its exhibition. His response appears to have been to go beyond Matisse in the appropriation of African cultural models, and to deepen his acquaintance with African and other non-western artifacts in the Trocadéro Museum in Paris. He had previously seen African masks and figure sculptures in Matisse's studio, as well as those of Derain and Maurice de Vlaminck, in late 1906 but, until his encounter with the *Blue Nude* and his subsequent museum visit, had shown little interest either in the dark continent or in adopting its cultural forms. In the summer of 1907, he did both, and the result was the harnessing of the supposedly magical and fetishistic connotations of tribal masks and figures in the production of what he later called 'my first exorcism painting'.

Like the paintings of Matisse and Derain, the *Demoiselles* images an 'otherness' that is an amalgam of sex and race. But as art historian Anna Chave observes, where the other artists contrived 'a safe, masculinist pornotopia' whose *frisson* of barbarity was, for contemporary audiences, alleviated by classical reference and pastoral location, Picasso composed 'a dangerous, masculinist dystopia set in a Paris abruptly invaded by elements of black Africa'. If that invasion contributes strongly to the aggressive and disturbing character of the picture, it is the sexual charge that is paramount; ultimately, however, the two are inextricable. For Sigmund Freud, white women were themselves 'the dark continent'; many men of his generation would have agreed with a metaphor that expressed both the mystery and the threat that women presented to their understanding of the world, and that precipitated a crisis of masculinity in many European societies during the years around 1900.

At the turn of the century women across Europe and north America were laying claim to new opportunities placed within reach by liberal capitalist societies: social mobility, democratic citizenship, educational and professional advancement – and in France were starting to win some equality in the middle-class professions, in the proletarian workforce and even, in some respects (but not that of voting rights) before the law. The response from men of all classes and political allegiances was both to stress the uniquely domestic and maternal role of women (indeed to develop complicated theories to argue that this role was biologically determined), and to consolidate those cultural forms and leisure activities that were exclusively male, from anti-feminist treatises, novels and plays to team sports like soccer and rugby, which were underwritten by a cult of action. The artistic avant-gardes were no exception to this, for as the art historian Carol Duncan observed in a pioneering article, 'from this decade

10
Babangi mask from the French Congo

Musée Barbier-Mueller, Geneva

dates the notion that the wellsprings of authentic art are fed by the streams of male libidinous energy'. Collectively, the work of these avant-gardes 'defines a new artist type: the earthy but poetic male, whose life is organised around his instinctual needs'. The rejection of bourgeois social habits that was typical of the 'bohemian' lifestyle of their members thus had as its corollary a return to pre-bourgeois sexual relations, and the exclusion of women as equals in the collective vanguard endeavour. More than anything else, as Duncan noted, 'the art of this [pre-war] decade depicts and glorifies what is unique in the life of the artist – his studio, his vanguard friends, his special perceptions of nature, the streets he walked, the cafés he frequented'.

It was thus characteristic of that ~~avant-guerre,~~ avant-garde community, ~~and of its~~ prototypical member, Picasso, that the next stage of his career after the *Demoiselles d'Avignon* should have been pursued as a collective project. This extraordinary seven-year adventure, out of which emerged many of the defining features of Cubist art and most of its major paintings, was embarked upon with the support of a small group of friends – the *bande à Picasso*, including poets Guillaume Apollinaire, André Salmon and Max Jacob – and in close partnership with another (male) artist, Georges Braque. Each of the two principals later described their relationship in a memorable phrase, Braque recalling that they were like two climbers roped together on a mountain, Picasso remarking that the former 'was my wife'. Both metaphors indicate the closeness of a working partnership that even led them, for a short time in 1911 and 1912, to efface their individual personalities in the joint exploration of new pictorial means, making almost identical paintings to which they put no signatures. Neither phrase, however, captures the spirit of rivalry that accompanied the partnership and fuelled the daily dialogue between the two over nearly four years, from 1909 to 1912.

The dialogue began slowly. Braque, digesting the lessons of the *Demoiselles* more quickly than most, in late 1907 made a drawing of *Three Nudes* of which two were fairly closely copied from Picasso's painting and whose overall composition attempted to follow the latter in the interlocking of surface and depth, to produce an illusion of low relief that is almost sculptural. He then worked the drawing up into a single-figure painting, *Large Nude*, in time for the Salon des Indépendants in the spring of 1908 (figs.11, 12). Less successful than the drawing in accommodating the radical flatness and figural distortions of the *Demoiselles*, Braque's painting appears tentative, its startling combination of views of the figure's front and back juxtaposed unconvincingly with the more or less conventional space in which the figure is set. As in Picasso's work, there is a good deal of Cézanne in this picture; unlike Picasso, though, Braque was less concerned to challenge the latter than to learn from him. Thus they differed in their adoption of one of

Cézanne's key devices, that of *passage* — the use of parallel short, hatched strokes of paint, often arranged in diamond- or lozenge-shaped patches, to ease and disguise the transition from shallow to deep space in a picture, or to soften the contour boundary between solid and space, figure and ground

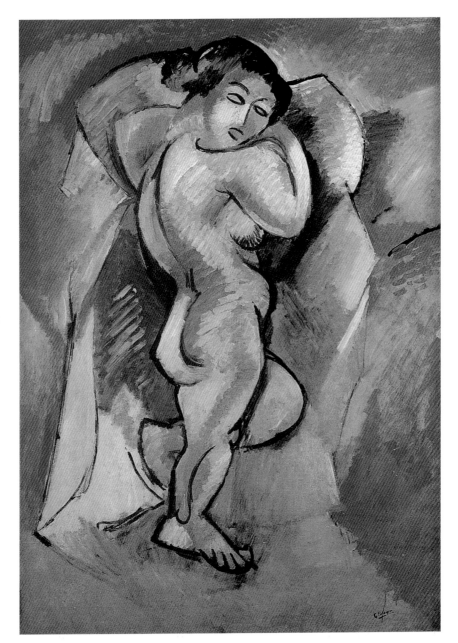

11
Georges Braque

Three Nudes 1907

Ink on paper
Reproduced in
Architectural Record,
Boston, May 1910
British Architectural
Library, RIBA, London

12
Georges Braque

Large Nude 1908

Oil on canvas
140 × 100
(55¼ × 39½)
Private Collection

(as, for example, in the National Gallery's *Bathers*, in the areas around the heads of the central and right-hand figures). In Picasso's adoption of it, *passage* tends to call attention to itself *as* a device; thus in the *Demoiselles*, in the breast area of the top right nude, a hatched diamond shape reads both

anatomically and as arbitrary shading. Braque's use of it, by contrast, is more in keeping with Cézanne's, areas of *passage* serving in the *Large Nude* to mediate between the figure and her surrounding space even as they imitate the uncompromisingly flat shapes of Picasso's picture.

It was over this terrain that the two artists drew steadily closer in the course of the next two years. As Picasso sought to avoid the traps both of the orthodox formulae of current painterly practice and of his own extraordinary facility, absorbing the examples of marginalised or disregarded art (not only African, but also the painting of self-taught independents such as Henri Rousseau) in the search for a formal vocabulary with which to express — and to exorcise — feelings about his sexual and artistic identity, he kept coming back to Cézanne. And as Braque wrestled with the formal implications of the *Demoiselles*, he found on the one hand that they showed the way beyond Cézanne to a radically self-referential kind of painting that could place the conventions of pictorial illusion at the centre, as it were, of the picture, and on the other hand that Cézanne's method provided a sheet-anchor against the dizzying exuberance of Picasso's iconoclasm. The differences, and the similarities, between them are clear from a comparison of two paintings made in August 1908: Braque's *Houses at L'Estaque* and Picasso's *Cottage and Trees* (figs.14, 15). Painted in Cézanne country, the Braque resonates with reference to the master of Aix: in its colour scheme in particular, but also in the geometric simplifications of its motif, and the hatched brushwork with its occasional patches of *passage*. Yet unlike Cézanne, Braque pushes the juxtaposition of different perspectives to the point of contradiction, and underscores it with a quite arbitrary distribution of light and shade; rooflines fail to meet walls, spaces and solids are elided, buildings are stacked up against one another like playing cards, and in the absence of a horizon the landscape is compressed into the space of a low relief. The Picasso, painted in La-Rue-des-Bois, a village in the Ile de France, is comparable in many of these respects: its motif is identical, its palette equally reductive; buildings, walls and trees are remarkably alike in style, disposition and (arbitrary) lighting. Yet in this case the effect is quite unlike that of low relief: instead, Picasso has so emphasised the juxtaposition of viewpoints — pulling the garden wall down and pushing the house up as if opening a pair of jaws — that the space between these features yawns wide. Borrowing Rousseau's sharp, surface-hugging linear style and its volumetric simplifications (fig.13), Picasso independently emphasises each element — volume, line, plane, light and shade — even at the expense of compositional unity. The effect is to maximise the dynamic effect of the painting.

If the increasingly close engagement of these two artists with each other's painting and that of Cézanne was changing their working practices — Braque's *Large Nude* was his first ambitious figure painting, while Picasso painted more landscapes in these years than ever before — they still remained quite distinct. Braque was continuing the interest in painting modest-sized landscapes and still lifes that had characterised his Fauve years, while Picasso followed up the *Demoiselles* with further ambitious, large-scale figure

13
Henri Rousseau

*The Banks of the Bièvre near Bicêtre c.*1904

Oil on canvas
54.6 × 45.7
(21½ × 18)
The Metropolitan Museum of Art, New York. Gift of Marshall Field, 1939

14
Georges Braque

Houses at L'Estaque 1908

Oil on canvas
73 × 59.5
(28¾ × 23½)
Kunstmuseum, Bern. Hermann and Margrit Rupf-Stiftung

15
Pablo Picasso

Cottage and Trees (La Rue-des-Bois) 1908

Oil on canvas
92 × 73
(36¼ × 28¾)
Pushkin State Museum of Fine Arts, Moscow

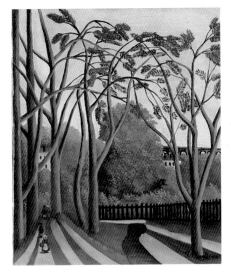

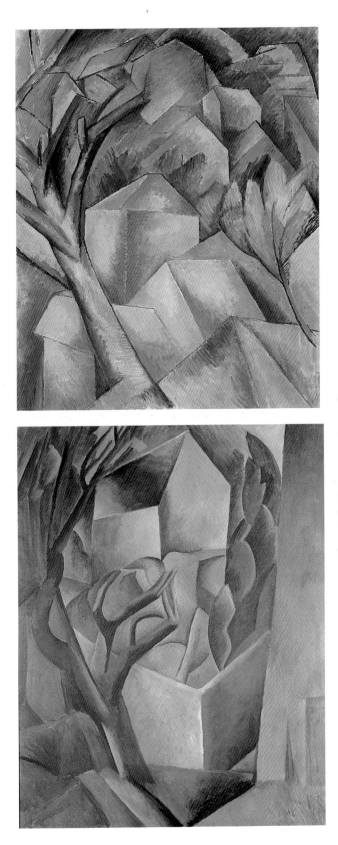

projects. Although Picasso withheld his work from salon exhibition, as befitted a rising star of the avant-garde he made his major pictures according to a 'salon' rhythm, progressing each project through a series of studies whose accumulated conclusions were then carried into the final painting. A series of works made in the winter of 1907–8 on the theme of nudes in a forest eventually resulted, after several months' toiling and a complete repainting, in the huge *Three Women* (fig.16), which Picasso finished

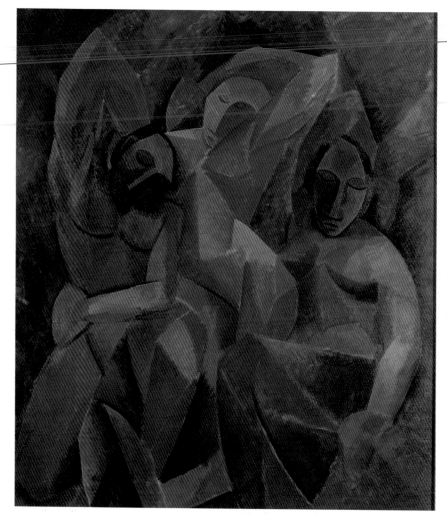

16
Pablo Picasso

Three Women 1908

Oil on canvas
200 × 185
(78¾ × 73)
Hermitage,
St Petersburg

in late 1908. An evident successor to the *Demoiselles*, it also registers his efforts to absorb and resist the lessons both of Cézanne and African masks. Though monumental and magisterial, in formal terms both more resolved and more radical than its predecessor, it was the last figure group that Picasso was to complete for several years, for in the middle of his next major project, his working procedure abruptly changed.

In the winter of 1908–9 Picasso began preparatory drawings and sketches for a big picture of five figures seated at a drop-leaf table in a café, being

served by a sixth standing figure bearing a bowl of fruit. Before it could progress to completion, however, the project, provisionally entitled *Carnival at the Bistro*, underwent an extraordinary transformation. By the spring of 1909 it had ended up as *Bread and Fruit Dish on a Table*, in which only the table remained, while the items depicted on it – loaves of bread, dish of fruit, napkin, upturned coffee bowl – eerily echoed the disposition of the limbs of its previous occupants (figs.17, 18). As art historian William Rubin argues, this decisive mid-stride change of direction, which he summarises as a shift from a 'narrative' to an 'iconic' approach (roughly, from questions of identities and relationship to questions of representation), was related to Picasso's growing preoccupation with the pictorial issues that Braque was drawing out of his study of Cézanne, and the associated realisation that the elaboration of complex figure compositions was superfluous to these issues. But it was also related to a fundamental change in his material and professional circumstances.

It was at this moment that the art dealer Kahnweiler began to narrow the

17
Pablo Picasso

Study for 'Carnival at the Bistro' 1909

Ink and pencil on paper
24.1 × 27.4
(9½ × 10¾)
Musée Picasso, Paris

18
Pablo Picasso

Bread and Fruit Dish on a Table 1909

Oil on canvas
164 × 132.5
(64½ × 52¼)
Öffentliche
Kunstsammlung Basel,
Kunstmuseum

range of his acquisitions, undertaking to buy from Picasso and Braque, at agreed rates, every picture they painted. He did so for two reasons: first, his faithful clientele of collectors, though still numbering fewer than a dozen, had become sufficient to support such a policy. Second, in the context of the emergent speculative market for new art, the prospects for Picasso's stock in particular were very promising, even though diminished in the eyes of some by his peculiar new paintings – indeed *because* they were diminished, since the hesitation of other players in this market created opportunities for risk-takers, of whom Kahnweiler was certainly one. The consequences for both Braque and Picasso were more than financial, confirming their own sense of the importance of the pictorial dialogue on which they were embarked – indeed in the latter's case they were even greater, for Kahnweiler's support removed self-promotional avant-gardism from the set of motivations that lay behind the series of large-scale, figure-group projects. From the spring of 1909 Picasso no longer painted for a putative salon public, but for the small audience of those who had already invested

enthusiasm, money or both in his art – Braque, the *bande à Picasso* and Kahnweiler's collector clients. His working procedure changed accordingly: for the next four years he would progress, not from project to project, but from painting to painting in an extended dialogue with Braque in which each work was a fresh point of departure for a sustained exploration and interrogation of the conventions of pictorial illusionism. The results of these interrogations were paintings accessible only to this small audience of initiates, for they were dense, difficult to read, elliptical in their inter-reference (figs.19, 20).

This so-called 'hermetic' or 'analytic' phase of the Cubism of Picasso and Braque thus emerged both out of their collective painterly experiments and the change in their professional circumstances, which replaced a putatively

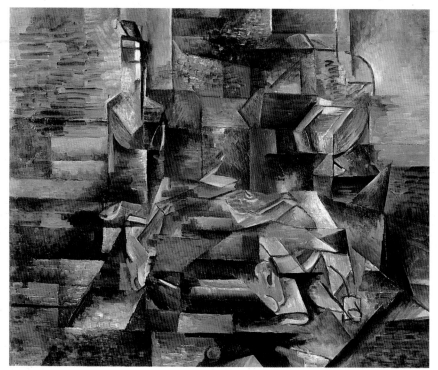

19
Georges Braque
Bottle and Fishes 1910
Oil on canvas
61.6 × 74.9
(24¼ × 29½)
Tate Gallery

20
Pablo Picasso
The Dressing Table
1910
Oil on canvas
61 × 46 (24 × 18¼)
Whereabouts unknown

public audience with a private one; but it also reflected, on the profoundest level, the nature of that more general avant-gardism whose emergence I outlined earlier. The ways in which these complex and mysterious paintings called the very basis of pictorial representation into question, revealing its linguistic and conventional character, owed much not only to Cézanne but to the symbolist poet Stéphane Mallarmé (1842–98), whose often arcane and difficult writings sought to suggest what he called the incantatory power of words, the 'magic of letters'. 'To evoke purposely, in a shadow, the silent object, with words that are never direct but allusive, subdued to an equal silence, requires an endeavour close to creation', he once wrote in what could serve as an explanation of Picasso's 1910 work, *The Dressing Table* (fig.20). Picasso in particular shared Mallarmé's belief in

a reality beyond appearances, to whose truths the artist and the poet had privileged access. Nothing could have been further from the Third Republic's confidence in an acquisitive and scientific materialism – the belief that reality was what you could lay your hands on – than such an aestheticism, and in the decade before 1914 it became a defining component of avant-garde identity.

That identity became, indeed, more sharply defined during the pre-war decade, as the social activism in which many artists had been caught up during the years of the Bloc des Gauches was succeeded by aesthetic militancy, a development that was reflected on one level in the proliferation of self-promotional tactics by young and/or anti-academic artists. Picasso's series of large-scale figure projects was, among other things, one such tactic, as I have suggested. Another was the attempt by a group of artists to obtain a distinctive profile within the salon itself; in the Salon d'Automne of 1905 Matisse, Derain and a few other painters of brightly coloured, loosely painted pictures had been singularly successful in this, obtaining for themselves the central foyer or *cage* in the exhibition-rooms and subsequent notoriety as the 'wild beasts' – *les fauves* – of contemporary art. Even more notorious, five years later, was the public launch of salon Cubism. Drawn together during the course of 1910 by the discovery of a shared set of aesthetic interests, by the evident similarity of the pictorial concerns displayed in their entries to the Salon d'Automne of that year, and through the efforts of sympathetic critics Guillaume Apollinaire and Roger Allard, five painters – Albert Gleizes, Henri Le Fauconnier, Jean Metzinger, Fernand Léger and Robert Delaunay – who, unlike Picasso and Braque, had no regular access to a private gallery, decided to exhibit their work together at the Salon des Indépendants in April 1911. This required first the abandonment of the Indépendants' policy of exhibiting its (unjuried) entries in alphabetical order, and then the allocation of a room largely to themselves. After a carefully organised campaign of lobbying, they secured both. The resulting exhibition-within-an-exhibition in room 41 was a gratifying *succès de scandale*.

Such self-promotional tactics were more than a matter of jockeying for publicity, however, for they played a key part in the construction of the very identity of the avant-garde artist. First, they helped settle the question of gender: such attention-seeking, career-advancing behaviour was no more appropriate for women artists in the regressively sexist milieux of the avant-gardes than was the display of sexual appetite. It is significant that, although Sonia Delaunay was the artistic as well as marital partner of Robert, she found no place in room 41 (indeed, in these years when he was first making his name, she abandoned painting for decorative art – a move that we shall explore in a later chapter). And while there *were* female participants in room 41 – Marie Laurencin and Maroussia Rabannikoff – their inclusion was at the insistence of their partners, respectively Apollinaire and Le Fauconnier, rather than the result of any perceived resemblance between their paintings and those of the others.

Second, such tactics helped to determine crucial qualities of the art that

they were used to promote: the size of the pictures these salon Cubists painted, how they painted them, even what they chose to paint. For room 41, each of the five painted his largest picture to date (and continued to show progressively larger works in every subsequent salon for the next two years). While artists had been aware for several centuries of the advantages that large scale gave to a picture's visibility on a crowded exhibition wall, such scale was also a declaration of serious intent – as it was also in Picasso's case with the *Demoiselles* – the more so when it was the vehicle for addressing a self-evidently ambitious subject. The female nude was one such, both hallowed by tradition and, in the wake of Cézanne's achievements, a marker of avant-gardist purpose (not to speak of avant-gardist virility). It was thus no coincidence that – again like Picasso – three of the salon Cubists made their group début with paintings on this subject. Of these the most celebrated at the time was undoubtedly Le Fauconnier's *Abundance* (fig.21). Extraordinarily, since to modern eyes it appears a ponderous and awkward treatment of a thoroughly conventional theme, this was perhaps the best-known Cubist painting in the pre-1914 period, exhibited in cities from Amsterdam to Moscow, and its author was regarded for a brief moment as one of the most radical painters in Europe. That this should have been so was due in part to the painting's articulation of a set of concerns that will be more fully discussed in the following two chapters: the relevance for contemporary cultural practice of the classical tradition and its associated values, and the question of how, if at all, this could be reconciled with the burgeoning forces and effects of modernisation. Thematically anchored to that tradition, *Abundance* also sought to update it by presenting the principal two figures, mother and child, in juxtaposition with the fruits of nature, in an implicit representation of the vitalist ideas of philosopher Henri Bergson – whose writings on the importance of the *élan vital*, or life force, were then widely influential in Parisian literary and artistic circles. Moreover, it sought to represent this vitalism in formal as well as iconographic terms, by endowing not only these figures but the picture surface as a whole with a density of volumes appropriate to the theme of fruitfulness, drawing, like Braque and Picasso in 1908, on Cézanne's brushwork and device of *passage* for the purpose.

The evolution of Le Fauconnier's painting was closely followed by the other salon Cubists, and its formal motifs adopted in their room 41 entries – in particular by Léger and Gleizes. Léger's *Nudes in the Forest* (fig.22) was an uncompromisingly bold, if not altogether coherent, attempt to maximise the dynamic potential of Le Fauconnier's technique. Gleizes's *Woman with Phlox* (fig.23) sought more static and monumental effects with the same volumetric and heavily painted means. It was their common interest in these stylistic features – a quality of physical density, conveyed by the fragmentation of forms into shapes that are evenly distributed across each canvas, and unified by a consistently sombre colour scheme that avoided bright or sharply varied hues – that both drew these artists together and gave salon Cubism its distinctiveness, in the eyes of the critics who saw and wrote about room 41. It was also the overlap between such concerns

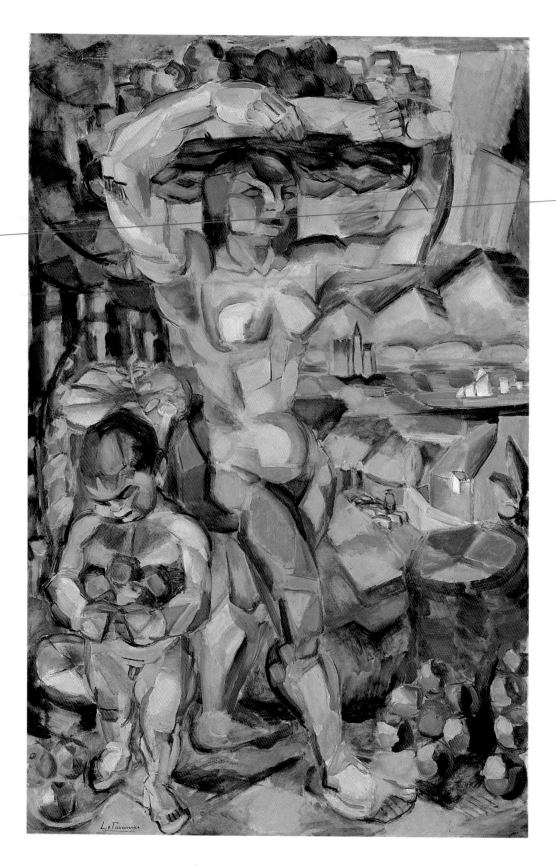

and those of Picasso and Braque two or three years earlier that laid the foundations for the broadening of Cubism into a movement that encompassed both gallery and salon orientations, and that has led many historians to see the latter as derivative of the former. As we shall see, however, these overlapping concerns were arrived at by routes that were different, if convergent – and across an aesthetic terrain, moreover, whose mapping was the work not only of adventurous artists but also of critics and theorists.

For writing about their art, or getting sympathetic critics to do so, was a third promotional strategy, alongside the painting of big, ambitious pictures and collective exhibition. Such activity had been an integral part of the art market since its beginnings, but the surfeit of aspirant writers and artists in Paris around 1900, together with the revolution in merchandising techniques, provided propitious circumstances for it to flourish in the pre-war decade. Marinetti's launch of Futurism in 1909 showed the way, his manifesto in *Le Figaro* ensuring that the term had wide currency long before any concrete examples of this new 'ism' were on the market, and as Jeffrey Weiss has shown, 'Cubism' was a term coined two years in advance of the group début of room 41 by an art public already primed to seek out (if only to ridicule) fresh novelties. By the spring of 1909, prompted perhaps by the cubic shapes in Braque's *Houses at L'Estaque* – exhibited by Kahnweiler the previous November – the term had acquired currency as a synonym for stylistic excess. Le Fauconnier in particular was quick to see the promotional potential of such a situation, in 1910 writing a personal manifesto, couched in impressively obscure pseudo-scientific jargon, which circulated first among his friends and subsequently across the pan-European avant-garde network that had mushroomed over the previous decade, earning him instantly the status of theoretician. It was probably for this reason, rather than because of his prowess as a painter, that *Abundance* was taken as paradigmatic of Cubism in 1911. Such avant-gardism was not only capable of making a reputation, however; it could also be the cause of an artist's downfall.

21
Henri Le Fauconnier
Abundance 1910–11

Oil on canvas
191 × 123
(75¼ × 48½)
Haags
Gemeentemuseum,
The Hague

2

LANGUAGES OF CLASSICISM

'A national literature, a renaissance of classicism; from 1908 to 1911 these
notions were passionately debated everywhere', wrote the literary historian
Michel Décaudin, adding 'but they were often mixed with political options
that modified at once their meaning and their resonance'. Those options
were explicitly understood at the time: as early as 1905 the critic Camille
Mauclair, writing on 'The Nationalist Reaction in Art', tellingly criticised
the current vogue for classicism as encoding cultural snobbery and aversion
to democracy. 'A love of M. Ingres ... of pastiches of Greece or the 17th
century, goes together unfailingly with reactionary opinions', he declared. 'It
is all a matter of "good behaviour".' For some – those who joined Charles
Maurras's monarchist, antisemitic and ultra-nationalist Action française – it
was more than that: a return to the principles of the classical culture of the
century of Louis XIV was imperative if France was to be rescued from the
disastrous consequences of the Revolution. And, for its squads of young
thugs – the *Camelots du Roi* – who intimidated its opponents in the university
quarter of Paris from their foundation in 1908 until the war, 'good
behaviour' had nothing to do with it. For other traditionalists such as
Maurice Barrès, however, both nationalism and classicism were more
inclusive, embracing the political settlement of the republic and
contemporary cultural innovations, since as he argued, 'if one is a
traditionalist, and submits to the law of continuity, one must take things as
one finds them'. Indeed, he defined nationalism as itself a form of
classicism: 'it is in every field the incarnation of French continuity.'

In the closely overlapping circles of the literary and artistic avant-gardes of Paris, these preoccupations were widely shared. When in 1905 a questionnaire offered readers of the *Mercure de France* a choice between Gauguin, Henri Fantin-Latour and Cézanne as the model for contemporary painting, most chose Cézanne, whose achievements they understood in terms that were summarised by the former disciple of Gauguin, painter Paul Sérusier: 'If a tradition is to be born in our time, it is from Cézanne that it will come', he replied. 'Not a new art, but a resurrection of purity, solidity, *classicism*, in all the arts.' His friend, leading art theorist Maurice Denis, went further, in two influential articles interpreting the paintings of Gauguin and van Gogh as preparing the way for the exemplary classicism of Cézanne, and declaring that 'in literature, in politics, the younger generation has a passion for order. The return to tradition and to discipline is ... unanimous.' He championed the cause of Action française as an answer to 'the present needs of our sick and divided society.' Young art critic (and, from 1911, editor of the influential *Nouvelle Revue Française*) Jacques Rivière declared the same allegiance: 'I prefer Action française, none of whose stupidities escapes me', he wrote in 1908 to a friend, 'to the radical-socialist league, for which I feel a truly physical repugnance'.

For young artists negotiating their way through the legacy of post-Impressionism and Symbolism the classical paradigm, underscored by a series of major retrospective exhibitions – of Jean-Auguste-Dominique Ingres in 1905 and 1910, Cézanne in 1907, Jean-Baptiste-Camille Corot in 1909 – was inescapable; though what each of them took from it differed greatly. Gleizes and Le Fauconnier met in 1909 in the literary milieu of Montparnasse. Drawn together by a common search for an art that was more solid and definitive than Impressionism, they found this in paintings of the Renaissance and the work of Jacques-Louis David and Ingres, and spent the next two years in joint exploration of the constructional principles that underlay this art, trying to fathom these by elaborating endless compositional schemas, as Gleizes later recalled, adding that these were visible in their paintings of the time: 'lines and volumes, densities and weights, symmetries and equilibria ... such were our interests and aspirations.'

Le Fauconnier's *Abundance* (fig.21) is a product of these concerns. It is so structured as to place the main figure's abdomen at the exact centre of the picture, and other salient anatomical and vegetable features on its major geometric axes. While it is usually possible to find all kinds of such 'secret geometries' in most paintings if one looks hard enough, it seems unlikely that these placements were coincidental. Artists and writers alike had, since before the turn of the century, been exploring ways of expressing ideas and emotions in painting or writing through abstract means: non-naturalistic colour, or irregular verse rhythms – or geometrical systems of composition. In the circles of writers and painters associated with the Symbolist movement and its rejection of dominant materialist thinking, there was much interest in the neo-Platonic tradition, which stemmed from classical Greece via the Renaissance, and according to which, mystical truths were

revealed through symbolic geometries. The most famous of these, the 'golden section ratio', was the subject of particular interest in the milieu in which Gleizes and Le Fauconnier met, and it is likely that it was among those constructional principles that they sought in classical and neoclassical paintings.

The arcane character of neo-Platonic thought corresponded well, moreover, with avant-gardist elitism; Le Fauconnier's 1910 manifesto was laced with its numerological jargon, and this in turn was imitated by other writers on emergent salon Cubism. Prominent among them was the young poet Roger Allard, who made his début as an art critic with a review of the 1910 Salon d'Automne. Singling out for praise the work of Gleizes, Le Fauconnier and Metzinger, he declared a beautiful picture to be 'nothing other than a true equilibrium, an equivalence of weights and a harmony of numbers'. But Allard added to this avant-garde classicism an interpretation that was to prove influential. The paintings of these three, he declared, 'offer to the intelligence of the spectator, in all their pictorial plenitude, the essential elements of a synthesis situated in time' – this, he argued, was because the equilibrium between their component forms took the spectator a certain amount of time to discern. In an article the following year he elaborated his ideas with specific reference to the seventeeth-century classicism of Nicolas Poussin. It was the balance that this artist achieved between the dynamism of his figures and the stasis of his compositions that gave his paintings a *living* beauty, one that must be intuited rather than analysed. 'Thus to love the living work for the vital forces that are in it', Allard argued, 'is to understand and possess nature, since by an act of genius a human thought has known how to contain it whole'.

Allard's emphases on time, movement, vitality and intuition were, in 1910–11, unmistakable references to the ideas of Henri Bergson. The philosopher's extraordinary celebrity in the pre-war decade was due to the way in which those ideas caught, in several respects, the complex mood of the moment. His emphasis on time (*la durée*) as the basis of reality – on the recognition that the world never stands still – matched contemporary awareness of the rapid pace of modernisation; his insistence on the importance of intuition, as against scientific analysis, chimed with growing anxieties over the urban and technological consequences of that modernisation, for which scientific advances had been fundamental; and his celebration of the *élan vital*, or life force, reinforced a corresponding nostalgia for a mythic, pre-modern and rural France governed by the rhythm of the seasons. It was a philosophy that could be, and was, used to support a variety of (sometimes contradictory) political and cultural platforms, and this adaptability ensured that Bergson's name was, for a while, ubiquitous.

For the circles in which the emergent salon Cubists moved, Bergson was significant in all these respects, since they contained some writers and artists who were enthusiastic about the dynamism of modern urban society, and others who were less sanguine. For painters on both sides, Allard's Bergsonist interpretation of classicism reconciled their interest in moving beyond Impressionism to a more monumental and less anecdotal art with

22
Fernand Léger

Nudes in the Forest
1909–11

Oil on canvas
120 × 170 (47¼ × 67)
Kröller-Müller Museum,
Otterlo

23
Albert Gleizes

Woman with Phlox
1910

Oil on canvas
81.6 × 100.3
(32⅛ × 39½)
The Museum of Fine
Arts, Houston. Gift of
the Esther Florence
Whinery Goodrich
Foundation

their concern to represent (in both positive and negative ways) the dynamic character of modern life. These qualities are discernible, in different degrees, in the paintings that Gleizes, Le Fauconnier and Léger showed in room 41 of the 1911 Indépendants. Like *Abundance*, the latter's *Nudes in the Forest* (fig.22) is both monumental and dynamic, its trio of classical nudes seemingly carved out of their pastoral setting, faceted into sharply juxtaposed planes and volumes by a patterning presumably derived from the dappling of woodland light and shade. Where *Abundance* seems timid

and awkward to modern eyes in this fragmentation of the picture surface, however, Léger's painting seems at once bold and incoherent. Its three female figures are so hard to discern that some observers have found four, and others have seen them as male, even as woodcutters; moreover, the extraordinary dynamism of its volumes is achieved at the expense of anatomical credibility, especially in the dancing figure at the right, whose limbs appear to be double-jointed and whose big toe is on the wrong side of her foot. Gleizes's *Woman with Phlox* (fig.23) stands, stylistically, midway between the *Nudes* and *Abundance*: the solid, even monumental figure of the seated woman is clearly legible, yet in an interior whose spatial organisation seems to have sacrificed clarity for dynamic effect. Like Léger it is as if, straining both to maximise the play of volumes and to lay bare the illusionistic devices from which they are constructed, Gleizes loses control of parts of the painting.

Whether these two pictures sought to follow the example of Le Fauconnier's in thematic, as well as stylistic, terms is uncertain. We can interpret the subject of *Woman with Phlox* both as symbolising a harmony between humanity and nature, which the dense play of volumes serves to underscore, and as an anxious celebration of the domestic role of women. This would certainly be in keeping with the message of *Abundance* as well as with some of the preoccupations of the salon Cubists' circle. But Léger's nudes seem to be simply a radical reworking of a traditional pastoral theme. In this they bear comparison to

the engagement of Picasso and Braque with the classical inheritance, in their paintings from around 1908 – in a pictorial dialogue which, as we have seen, drew them steadily closer together, but to which each brought quite different interests and aspirations.

Picasso, prodigiously talented and equally ambitious, had taken both the measure of that inheritance, and what he initially needed from it, some years earlier, his *Three Dutch Girls* of the summer of 1905 ushering in a phase in which classical and archaic art traditions were plundered for their qualities of simplicity and monumentality. The *Demoiselles* project and its associated encounter with African art took him away from these qualities, but he was led back to them partly by Braque's exploration of Cézanne's painting, partly by the contemporary obsession with classicism. The former of these was a consequence of the latter, for in many respects the contemporary designation of Cézanne as a classicist was appropriate. In his efforts to 'make of Impressionism something solid and durable like the art of the museums', as he once famously said, Cézanne had turned away from its engagement with the contemporary world of urban leisure, transport and industry to the pastoral themes of classical tradition, and even his depiction of landscapes with viaducts or factory chimneys gave these the air of monuments. In this, Braque followed him closely, his brief participation in the Fauve movement in 1906–7 almost a recapitulation of Cézanne's apprenticeship in Impressionism, before he too abandoned the

24
Georges Braque

The Viaduct at L'Estaque 1907

Oil on canvas
65.4 × 80.7
(25¾ × 31¾)
The Minneapolis
Institute of Arts

25
Nicolas Poussin

The Ashes of Phocion
1648

Oil on canvas
116.5 × 178.5
(46 × 70¼)
Board of Trustees of the
National Museums and
Galleries on Merseyside
(Walker Art Gallery,
Liverpool)

26
Georges Braque

Castle at La Roche-Guyon 1909

Oil on canvas
80 × 59.5
(31½ × 23½)
Moderna Museet, SKM,
Stockholm

Fauvist celebration of the dynamic modern city or port for the classical motifs of the Mediterranean coast. Explicitly revisiting Cézanne's motifs around L'Estaque, he monumentalised and classicised this tawdry suburb of Marseilles both by repeatedly featuring the viaduct with its connotations of Roman architecture, and by scaffolding its forms within stable rectilinear geometries and rationally ordered perspectives reminiscent of Poussin's severe and abstractly conceived landscapes (figs.24, 25).

Art historian Theodore Reff suggests that this change of theme on Braque's part, and the shift that it implied from a mode of painting centred on perception to one centred on conception, was related to that loss of confidence in modernity and withdrawal to the collective security of race, nation and tradition, that the classical revival represented for many. This may well be so; what is clear from the paintings however, is that, like

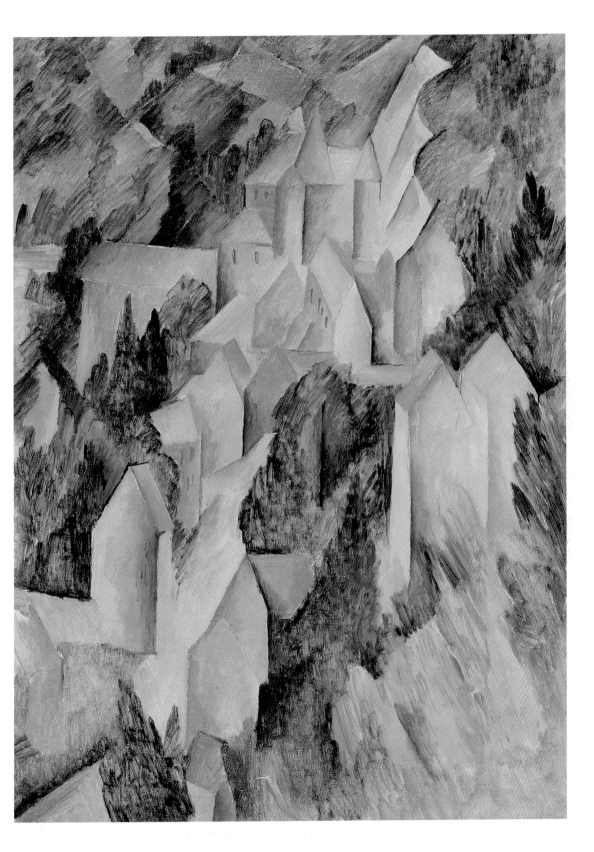

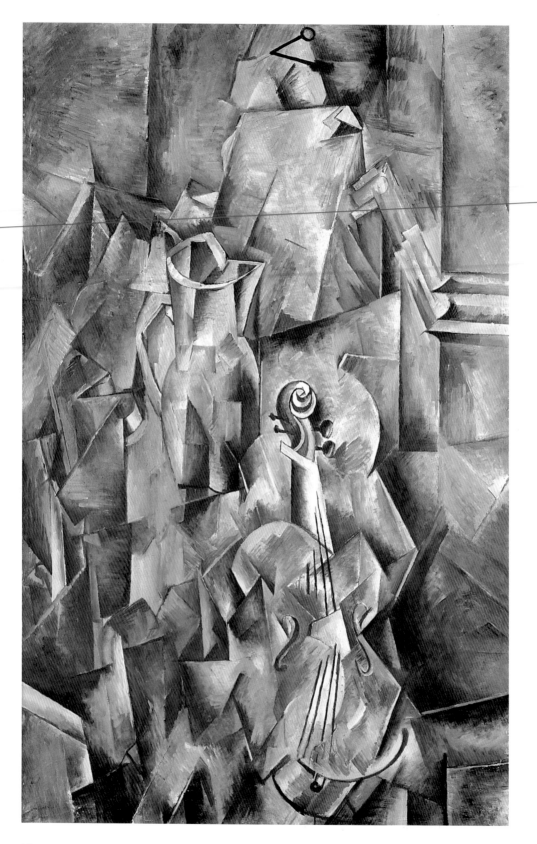

Cézanne, his pictorial concerns were not contained within the classical paradigm. If *Houses at L'Estaque* (fig.14) reprises, in its shallow relief-like space, its solid geometry and its framing trees, some elements of the classical formula, in other respects it goes so far beyond this as to subvert it. The inconsistencies and elisions, noted earlier, together call attention to the conventionality of painting – that is, to the rules of its conceptual game and the materiality of its means. In this and other paintings of that summer Braque learnt from Cézanne how the classical formula could be used to anchor and order the radical disruption of pictorial illusionism that Picasso was pioneering, but also how the rectilinearity of classical composition could itself disrupt that illusionism, by functioning as a sign for the picture surface. As yet, in *Houses at L'Estaque*, this possibility was only hinted at – the emphatic cube of the central house more than holds its own against

the flattening effects of the picture's scaffolding. A year later however, in a series of paintings of the emblematically French chateau of La Roche-Guyon, fifty miles north-west of Paris (fig.26), Braque developed the classical armature into a diagonal, linear grid, which he complemented with a pattern of diamond-shaped patches of *passage* brushwork. Together with a further reduction of his already limited Cézannian palette to little more than tonal variations of two colours, this enabled him both to deepen the ambiguities of the relationships between solids and spaces – sometimes even freeing shading from its ostensible function, to signify itself as a device (as in the upper centre of the *Castle*) – and to enhance the illusion of an overall low-relief space.

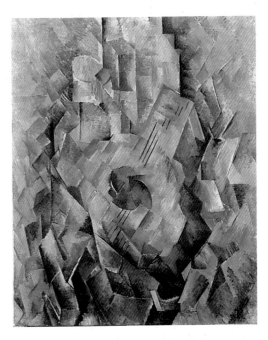

Over the following year Braque refined his conceit of the diagonal grid, capitalising on the ways in which it signified a painting's surface even as it conjured from it an image of depth, and the manner in which it pulverised its subject to reconfigure it in terms of its own properties of flatness and regularity. The interaction between these effects appears to be crucial; in paintings, such as the *Mandora* of the winter of 1909–10 (fig.28), when the classical order and systematic character of the grid predominate, the result is a loss of tension and a hint of stylisation. By contrast, in the *Violin and Pitcher* completed in early 1910 (fig.27) it is less explicit, a structure won through the effort of reading the image across a range of signifiers whose degrees of self-referentiality are wittily counterpointed by the *trompe-l'oeil* nail at the top.

Picasso's response to the classicism that Braque thus referenced and explored for complex reasons was, characteristically, to maximise such interactions and tensions. While his painterly dialogue with the latter and thus with Cézanne – not to speak of the ubiquity of classicist art and debate – drew him back to it, he had less regard than Braque for the order and harmony of classical art, and in the summer of 1909 his interest was not in exploring the ambiguities of shallow space so much as in disrupting its framework to the point of collapse. As in their paintings of a year earlier, his *Houses on the Hill, Horta da Ebro* (fig.29) shares a gamut of stylistic features with the *Castle at La Roche-Guyon*: a limited palette, diamond faceting, a plurality of viewpoints. In place of Braque's subtle elisions of solid and space, however, these viewpoints are juxtaposed with

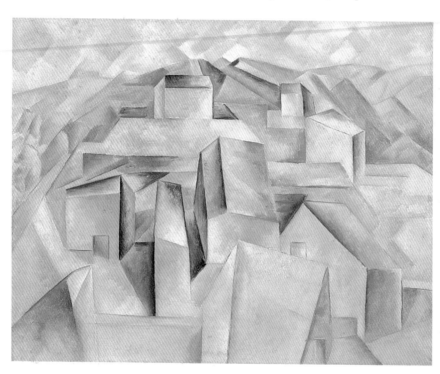

29
Pablo Picasso

*Houses on the Hill,
Horta da Ebro* 1909

Oil on canvas
64 × 81
(25¼ × 32)
The Museum of Modern
Art, New York

30
**Jean Baptiste-Camille
Corot**

*Gypsy Girl with
Mandolin (Christine
Nilsson)* 1874

Oil on canvas
80 × 57
(31½ × 22½)
Museu de Arte de São
Paulo Assis
Chateaubriand

31
Pablo Picasso

Seated Nude 1909–10

Oil on canvas
92.1 × 73
(36¼ × 28¾)
Tate Gallery

an abruptness and lack of logic that, as with Léger's *Nudes in the Forest* (fig.22), is both bold and bewildering. Unlike Léger's painting, however, the effect is not incoherence but recognition of the potential independence of pictorial devices such as linear perspective and chiaroscuro from their descriptive function, and thus of the possibility that they could themselves be the subject of paintings. For Picasso this represented a deepening interest in the linguistic character of pictorial expression – both in the ways that its conventions and components functioned, and, following Mallarmé, in its incantatory power and magical transformative capacities. If Braque's reworking of Cézanne was the stimulus, it was the encounter with another classicism that set the tone for the paintings that followed.

The exhibition in 1909, at the Salon d'Automne, of twenty-five figure paintings by Corot came as a revelation to both artists. Less well known than his landscapes, their gravity and austerity, and their play of volumes and spaces against plain studio backgrounds, matched not only the cultural mood of the moment, but also Picasso's current pictorial concerns, and in a series of figure paintings over that winter he absorbed their lessons (figs.30, 31). Reworking Corot's accommodations of sculptural volume and painterly flatness through his own radical syntax of angular facets, abrupt changes of viewpoint and the spatial ambiguities that Cézannian *passage* brushwork allowed, the *Seated Nude* develops the plasticity of the Horta painting into a monumentality that is as mysterious as it is austere, and at once contradicts this, opening out and flattening the contours of the figure

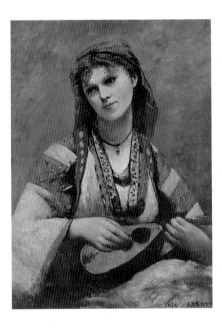
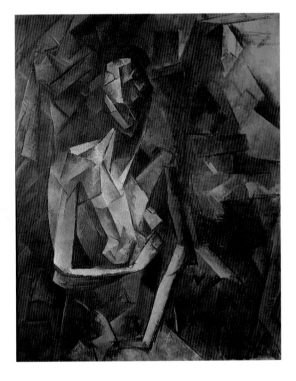

into the surrounding space. That the result is not incoherence is due partly to the deftness and beauty of Picasso's deployment of chiaroscuro and *passage*, and partly to the effect of the diagonal grid which, although only implicit, marshals the faceted forms of figure and ground into a unified pictorial field.

These devices were key features of the paintings of both artists in the year that followed, but it was Picasso who, perhaps learning from Braque's elaboration of the grid in paintings such as *Mandora*, made the more radical use of them. At Cadaqués in Spain in the summer of 1910, in the *Guitarist* (fig.32) and other pictures, he took the extraordinary step of detaching both the grid itself, and chiaroscuro modelling, from their descriptive purposes, leaving the former to function only as a set of co-ordinates by means of

which the picture's subject can be located, and the latter to articulate the pictorial field, sometimes suggesting the volumes of the subject and sometimes denying them. As art historian Yve-Alain Bois has suggested, this development can best be understood in semiotic terms, as a shift from one

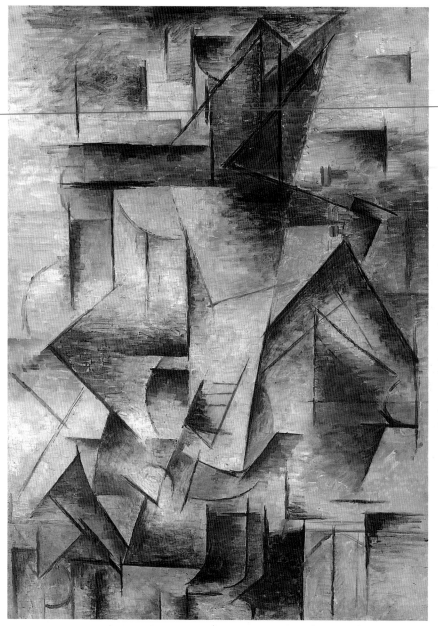

32
Pablo Picasso

Guitarist 1910

Oil on canvas
100 × 73
(39½ × 28¾)
Collections
Mnam/Cci/Centre
Georges Pompidou,
Paris

33
Jean Metzinger

Two Nudes 1910–11

Oil on canvas
Dimensions and
whereabouts unknown

kind of visual sign to another – from 'iconic' signs, which depend on resemblance to their pictorial subjects, to 'symbolic' signs, which depend instead on their place within the *system* of signs of which the picture is composed – and the differences between them. Thus in the *Guitarist*, the figure is legible not so much through the resemblance of any of its features

to a recognisable image of a guitarist, as from the relationship between diagonal and circular forms set against a rectangular lattice; from these we read a head (the cylinder at the top), arms (triangular shapes at each side) and a guitar (the repeated arcs in the centre). There is still a crucial, residual degree of resemblance – elbows are pointed, for example, and guitars have round sound holes – but it is the placing of these elements and their distinction from rectangular shapes in a system of signs reduced almost to a minimum, that are decisive.

In works such as this, Picasso took painting to the verge of abstraction. Neither he nor Braque were interested in going further; theirs was an art of realism not only because the question of representation of an external reality was at the centre of their exploration of the linguistic character of painting, but because – especially for Picasso – that external reality was simply too enticing to let go of. Braque's response was to retreat to the use

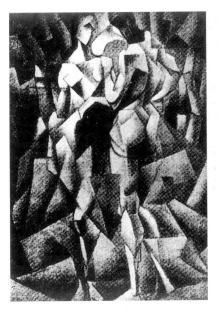

of iconic signs: his Chardinesque *Bottle and Fishes* of the autumn of 1910 (fig.19) reintroduces recognisable motifs (fish heads and a bottle) within a classical armature of verticals and horizontals, and even perspective recession. Picasso too returned to iconic signs – if anything, more wholeheartedly – but as a foil to a now dominant grid that he detached even more completely from any precise descriptive function. Thus in *The Dressing Table* (fig.20) the key in its hole (bottom centre), the mirror (top centre) and, less legibly, a bottle and a glass provide visual clues enabling the image to be read, while the grid extends across almost the entire picture surface, its chiaroscuro of neo-Impressionist brushstrokes conjuring up interplays and contradictions between volumes and spaces, transparency and opacity. Such loosening of the ties between signifier and specific signified – between the painted mark and the object it denotes – allows the imagery to be read on more than one level: thus the grid pattern also serves, wittily, to

denote the drawers and shelves of the painting's subject; even, as Robert Rosenblum has suggested, to hint at the absent figure of the woman whose dressing table this may be, the mirror and keyhole slyly signifying her face and her sex. This multiple function of the marks and devices in Picasso's Cubist lexicon was to prove, as we shall see, one of its most fruitful and influential features.

Given Picasso's reputation among the avant-garde milieux, it was inevitable that the explorations that led him and Braque into the hermetic Cubism of 1910–12 should attract attention, not only from their patrons and friends but from other artists, critics and hangers-on as well. The apparent convergence between their assessment and reworking of classicism and Cézanne, and that of the nascent salon Cubist group, was remarked on and encouraged by sympathetic critics, Apollinaire in particular. From early 1911

both camps were aware of each other – indeed there was one artist who managed to have a foot in each, and whose work has done much to create the mistaken understanding of salon Cubism as largely derivative of gallery Cubism. Jean Metzinger was in one sense a stereotypical avant-gardist. Gravitating, on his arrival in Paris in 1902, to the Montmartre community, he put himself through a rapid apprenticeship to the most adventurous styles of painting, from neo-Impressionism to Fauvism, and by 1907 had met Apollinaire and, through him, Picasso. Keenly responsive to new ideas and ascendant reputations, he was quick to imitate the neo-Symbolist poetry of the former and the emergent Cubism of the latter. Introduced by his friend Robert Delaunay to Le Fauconnier, Gleizes and Léger in 1910, he both recognised the affinities between their paintings and those of the gallery Cubists, and saw the chance to put himself, armed with Picasso's audacities, at the head of this salon-oriented group. In an article written in the autumn of that year he capitalised upon his unique position in order to discern comparable qualities in the paintings of Picasso, Braque, Le Fauconnier and Delaunay, praising both their individualism and their profound attachment to the tradition of the 'old masters'. His entry for the Indépendants the following spring displayed, if nothing else, his own absorption of lessons from most of these sources. Although its subject was perhaps chosen to rival Le Fauconnier's demonstration-picture *Abundance*, his *Two Nudes* of 1910–11 (fig.33) appears, from the black-and-white photo that is the only remaining record of it, to have been indebted in particular to classicism, on the one hand and, on the other, to Picasso's nude studies of a year earlier (fig.31). Metzinger's appropriation of both models, however, appears mannered and superficial, the figures possessing all the *gravitas* of fashion mannequins, and the geometries of their fragmentation serving little other than decorative purpose.

Over the months following the group début of room 41 Metzinger found, or positioned, himself at the centre of the salon Cubists' activities. By the autumn he was acknowledged as its leading figure, supplanting Le Fauconnier in that role both in the eyes of critics and within the group. This was especially true of Gleizes, whose *Landscape, Meudon* (fig.34), the product of a close working relationship with Metzinger over the summer of 1911, shows a clear debt both to the busy planar stylisations of Metzinger's *Two Nudes* and, partly through his example, to the classical tradition of Poussin and Claude Lorraine. For Gleizes through, unlike his new partner, this tradition stood for more than aesthetic values. *Landscape, Meudon* took as its subject an identifiable motif, the sweep of the Seine southwest and downstream of central Paris. In 1911, this area was the site of rapid industrialisation, as the Renault factories spread across much of the right bank; yet Gleizes represented this mushrooming suburb in clearly pastoral terms, the dynamic interplay of its planes and volumes expressive of the *élan vital* of nature rather than the momentum of automobile technology, and, together with the picture's classical composition, setting the cultural values of the country against those of the city, the past against modernity.

In the context of the rising tide of nationalism and social unrest in the years before 1914, such references as these by Gleizes had unmistakable ideological implications, as will be examined in the following chapter. Few others in the Cubist milieux engaged so directly with identifiable political currents, but as these milieux came increasingly to overlap during 1911 and 1912, their members socialising on Sunday afternoons at the house of the

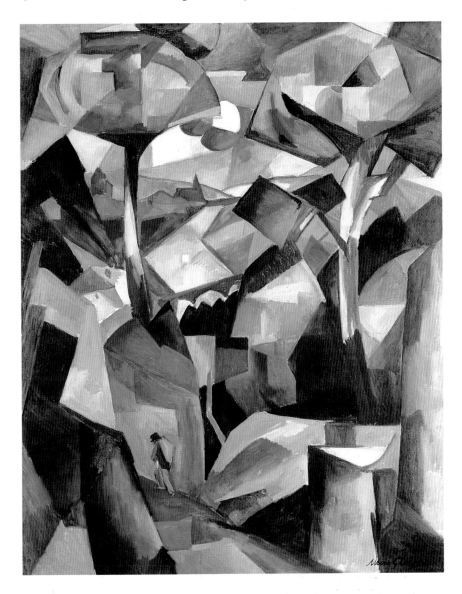

34
Albert Gleizes

Landscape, Meudon
1911

Oil on canvas
147 × 115
(58 × 45¼)
Collections
Mnam/Cci/Centre
Georges Pompidou,
Paris

Duchamp brothers in suburban Puteaux, it was on the shared ground of a profound, if variously motivated, commitment to traditionalism that the two wings of the movement met. Common to the discussions at Puteaux was the topic of number and geometry. This was a subject with a useful range of applications: it was fundamental to an interest in the concept of the fourth dimension, which the Cubists shared with many others, and

through which the scientific and mathematical developments of the recent past were popularly assimilated; it also attracted those painters exploring the basis of pictorial rhythms with which they could address the dynamism of the modern world. Most interest at Puteaux, however, was in the combination of traditional and avant-garde connotations outlined earlier: numerical and geometrical systems as the vehicle for the mystical Symbolism of the neo-Platonic tradition, as the underpinning of classical pictorial composition, and as the pseudo-scientific basis for an art based on intellect instead of sensation. Members of the group together read Leonardo's *Treatise on Painting* and other texts that discussed proportional systems, and experimented with the use of the golden section ratio in their paintings.

This interest found its most substantial expression in the project of an exhibition that would comprehensively demonstrate the strength, and the common concerns, of the newly consolidated grouping. The Salon de la Section d'Or (Salon of the Golden Section) was timed to rival the Salon d'Automne, opening ten days after the latter in October 1912. If far smaller, it was nevertheless impressively big for a group exhibition: thirty artists showed over 200 paintings and sculptures, indicating thereby not only the range of work that the movement encompassed but also the number of its adherents. As if the exhibition's title were not a clear enough signal of its traditionalist emphasis, this was hammered home by Apollinaire in his editorial for *La Section d'Or*, a collection of critical essays published to accompany and support it. With contributions from nineteen writers, this was itself a substantial production, a demonstration of the considerable weight that Cubism now carried in avant-garde circles. The longest and most analytical contribution, from Maurice Raynal, repeated Apollinaire's stress on tradition and gave this an explicitly classicist interpretation.

What was equally significant in Raynal's essay, however, was the partisanship it displayed vis-à-vis the currents within the Cubist movement that were represented in the Salon. Of the Bergsonian reconciliation of the classical tradition with the dynamism of modern life that characterised much of salon Cubism there was not a mention; instead, Raynal interpreted Cubism in aestheticist terms that were clearly sympathetic to gallery Cubism: 'What finer idea', he asked, 'than this conception of a *pure* painting, one that is in consequence neither descriptive, nor anecdotal, nor psychological, nor moral, nor sentimental, nor pedagogical, nor finally decorative? ... Painting, in fact, should be nothing other than an art derived from the disinterested study of forms ...'

As the most ambitious contribution to the *Section d'Or* volume, Raynal's essay marked a turning-point in the history of the Cubist movement, for it made it clear that here, as in the Puteaux group milieu from which the project sprang, the aesthetic and stylistic interests of gallery Cubism were in the ascendant.

3

PERSPECTIVES ON SIMULTANEITY

In the exhibition-within-an-exhibition that was room 41 at the 1911 Indépendants, the paintings of Robert Delaunay must have stuck out like a sore thumb. For all the radicalism of their representation, the pastoral nudes, portraits and domestic interiors of his co-débutant salon Cubists were traditional and time-honoured subjects; by contrast, Delaunay's three cityscapes of Paris, in particular a dramatic view of the Eiffel Tower, signalled an embrace of urban modernity and a celebration of its dynamism (fig.35). If this was characteristic of an individualism on the latter's part that would lead him to split from the group and go his own way within little more than a year, it was also an enthusiasm shared widely in the milieux of the avant-garde, as new technologies and forms of mass entertainment – the automobile, aviation, electric lighting, cinema, cycling, team sports – caught the popular and poetic imagination alike. The Italian Futurists coined a term, 'modernolatry', for this cult of the modern that characterised the first years of the new century, and the manifesto that launched their movement in 1909 was a good example of it. 'A racing car whose hood is adorned with great pipes ... a roaring car that seems to ride on grapeshot is more beautiful than the *Victory of Samothrace*', declared its author Marinetti. And he stressed its social dimension, promising that Futurism 'will sing of great crowds excited by work, by pleasure, and by riot; we will sing of the multicoloured, polyphonic tides of revolution in modern capitals'.

Parisian writers needed no prompting from Marinetti, and in the first decade of the century examples of literary modernolatry were

commonplace; Octave Mirbeau's *The 628-E 8* of 1908, for instance, was perhaps the most celebrated of a score of hymns to automobile dynamism published around that time. In the context of the vogue for Bergson's philosophy noted earlier, however, it was the distinctive character of modern urban experience that drew the attention of many. His concepts of duration (*la durée*), embracing past, present and future, and of the life force, or *élan vital*, which gave a collective momentum to the mental life of individuals, provided a framework for imaginative interpretations of that experience. For this aspect of the cult of the modern, another term, 'simultaneity', was coined, and quickly became a buzzword of the period. It had a variety of connotations. For the poet Jules Romains it signified the common, immediate experiences of the teeming metropolis that bound its inhabitants

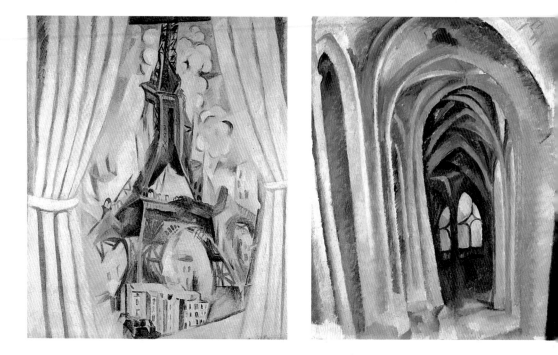

together. His epic lyric poem *La Vie unanime* (*The Unanimous Life*), published in 1908 to wide acclaim, celebrated the innumerable collectivities (of place, occupation, custom) that dissolved the individuality of each, subsuming all of which was the city itself: 'I am like a grain of sugar in your mouth, glutton city', he wrote. For the Futurist painters in 1912, the term had other, if related, meanings: 'the simultaneity of states of mind in the work of art: that is the intoxicating aim of our art', they declared. In order to capture the unprecedented dynamism of modern life, a picture must be 'the synthesis of what one remembers and what one sees'.

Robert Delaunay met Romains, and encountered the ideas of the Futurists, in 1909, and his interest in simultaneity overlapped with theirs. The subject of the Eiffel Tower, which he first painted that year, and to which he returned many times, was for him both an icon of the modernity

celebrated by the Italians and the focus of that collective metropolitan identity cherished by the poet, a defining feature of Paris shared by — simultaneously visible to — all of its inhabitants. But it was also the object of a more purely visual and painterly interest. The vertiginous height of the tower and the startling juxtapositions of scale and perspective that it repeatedly afforded as it loomed over buildings, or was framed between curtains, or closed a street vista fascinated Delaunay; moreover, the challenge that these visual sensations presented to pictorial representation brought together the painterly issues that most interested him. Lacking any formal art education, he had apprenticed himself first to Impressionism and then neo-Impressionism, learning from the latter the basics of colour science, but it was the joint encounter with the work of Cézanne and Henri Rousseau that proved formative. Like Picasso at La-Rue-des-Bois, he learned from these two painters lessons about the relationship between the picture surface and the illusion of depth; his Impressionist-informed interest in colour led him first, however, not to the conceptual simplifications and exaggerations of the *Cottage and Trees* (fig.14) but to perceptual concerns — to an exploration, in a series of paintings in 1909 of the interior of a Paris church, St Séverin, of the visual sensation of deep space and the role of colour and mobile perspective in its representation (fig.36).

The encounter with Romains and the Futurists inspired Delaunay to a radical development of these concerns, and one that shifted their centre of gravity from the perceptual to the conceptual. Substituting the tower silhouetted against the sky and framed by curtains for the column and aisle of St Séverin, he constructed that silhouette out of several juxtaposed views — the top of the tower seen from the air, the base splayed and flattened like a cardboard cut-out — and broke down its contours with shafts of light. The effect is not only to reduce drastically the illusory space of the picture, but to suggest a new understanding of its representation. 'A profile is never motionless before our eyes', the Futurist painters declared in their Technical Manifesto of 1910. 'On account of the persistency of an image on the retina, moving objects constantly multiply themselves ... To paint a human figure you must not paint it; you must render the whole of its surrounding atmosphere.' Delaunay painted his picture as if taking his cue from this very assertion, surrounding the tower with its ambience of light. Yet the juxtaposed views suggest not its mobility but its simultaneous visibility to all the city's inhabitants — one of whom is the salon viewer of the painting, whose subjectivity is both signalled by the equation of picture surface with window, and co-opted, by the combined and superimposed views of the tower, for Romains' unanimist collective of Parisians.

If Delaunay's painting stood, in thematic terms, at some remove from those of the others in room 41, there were evidently enough stylistic features common to them all to warrant his inclusion in the group début. Metzinger's *Two Nudes* shared its use of broken contours, the paintings of Léger and, less boldly, Gleizes, its distortion of perspective, and all of them, including Le Fauconnier's *Abundance*, its dynamic play of volumes. During

35
Robert Delaunay
Eiffel Tower 1910
Oil on canvas
116 × 97
(45¾ × 38¼)
Kunstsammlung
Nordrhein-Westfalen,
Düsseldorf

36
Robert Delaunay
St Séverin 1909
Oil on canvas
99.4 × 74
(39¼ × 29¼)
Minneapolis Institute of
Arts

the next year, moreover, all but Metzinger followed him into an engagement with the dynamism and simultaneity of modern life. It is likely that they too were motivated in part by avant-gardist rivalry with the Futurists, though not always to share their 'modernolatry'. The Italian painters visited Paris in the autumn of 1911, and met both salon and gallery Cubists; around the same time, Le Fauconnier began work on *The Huntsman* (fig.37), a painting

37
Henri Le Fauconnier

The Huntsman
1911–12

Oil on canvas
203 × 166.5
(80 × 65½)
Haags
Gemeentemuseum,
The Hague

38
Fernand Léger

The Wedding 1912

Oil on canvas
257 × 206
(101¼ × 81¼)
Collections Mnam/Cci/
Centre Georges
Pompidou, Paris

even bigger than *Abundance*. Exhibited at the Indépendants the following spring and intended clearly as a sequel, it incorporated not only the two principal figures from that painting but also the striking innovation of isolated vignettes (a railway bridge, a church, a villagescape) inserted – montaged, as it were – into the scene with no attempt to reconcile them spatially with it. An example of simultaneity as the Futurists understood it – a representation of 'states of mind', with the vignettes suggesting

remembered elements of the scene depicted – *The Huntsman* appears, however, to stand for the very opposite of Futurism.

Burdened by its author's theoretical ambitions, the painting is over-complicated and difficult to decipher. At its centre stands the huntsman, firing a shotgun at mallard ducks, some of which are scattering above and below him. It would seem that Le Fauconnier intended this figure to stand, at least on one level, for himself (or as 'the artist'). The huntsman is the origin, formally as well as thematically, of the dynamism of the picture: explosive, destructive and disharmonious, accompanied not only by gunsmoke and dead ducks but also by the figures of *Abundance* and her son, the representatives of a more mutually enriching relationship between humanity and nature. We can, therefore, infer an equation between the huntsman and the modern world of violence and metal, in which the latter is mediated by the artist, who discovers the visual language appropriate for

its expression. Such an inference is supported by certain details: the juxtaposition of the railway bridge with the church (emblems of the modern and the traditional); the emphasis, by isolation, of the firing mechanism of the gun; the dislocation of the countryside into scattered fragments of a landscape. If this inference is correct, and if these grandiose ideas were indeed Le Fauconnier's, they indicate a deepening of the painter's attachment to traditionalism, and of his pessimism in the face of modernisation.

On one level, the pessimism was perhaps justified in late 1911 and early 1912, for the prospect of imminent war with Germany had been brought closer than ever by the second Moroccan crisis of July 1911 and its repercussions. To suggest that *The Huntsman* was in any sense a direct response to diplomatic tensions would be absurd, collapsing into a crude binary relation of political 'cause' and artistic 'effect' the complex cultural movement within which Le Fauconnier's art practice was formed. Yet the crisis, in both heightening alarm at the prospect of war and giving further motivation to the projects of national self-definition surveyed earlier, could only have exacerbated the tensions between traditionalism and modernism, nationalism and avant-gardism that *Abundance* had inscribed.

Léger had no such qualms; he embraced both the visual dynamism and the social consequences of modernisation. Borrowing from the Futurists the concept of 'states of mind', and from Le Fauconnier the means of its representation, his huge *Wedding* (fig.38), also shown at the 1912 Indépendants, inserted views of the event between the fragmented forms of its participants – principal among whom can be identified the central figures of bride and groom – suggesting thereby that what the painting represents is a memory of this unanimist collectivity, a montage of

recollected features, rather than the scene as directly observed. Although as complex and indecipherable as *The Huntsman* it is a more successful painting in its 'simultaneity' because more controlled. Structured around oppositions between hard and soft forms, curves and angles, planes and volumes, its kaleidoscope of images swept by smoke-like wedges (mists of memory?) into a spiralling motion that anticipates the dizzy-spin device of Hollywood 'flashbacks', it marks, more clearly than Le Fauconnier managed to convey, the distinction between the conceptual and perceptual bases of painting.

The concept of 'simultaneity' as understood both by the Futurists and the salon Cubists registered this distinction, in its stress on the role of artistic invention in selecting and synthesising on canvas the mix of remembered and seen elements of a subject, to represent the experience of modernity. But the distinction also characterised another understanding of simultaneity that was central to Cubism: the juxtaposition or combination, in a single painting, of radically different and discontinuous perspective schemas or viewpoints. I suggested that Delaunay's use of this device in his *Eiffel Tower* of room 41 (fig.35) was one aspect of his pictorial response to the ideas of the Futurists and the poetry of Romains. But it had a likely source, too, in the paintings of Picasso and Braque that he and the other salon Cubists may have encountered for the first time at Kahnweiler's gallery in the winter of 1910–11, through the agency of Metzinger (Delaunay's close friend since 1906) and Apollinaire. Metzinger himself had adopted the device by then, as his *Two Nudes* (fig.33) demonstrates, the fragmentation of the legs and shoulder of the right figure in particular juxtaposing, to no great effect, different views of these in a manner that recalls Picasso's nude studies of the previous winter (fig.31).

As we have seen, the use by Picasso and Braque of such perspective juxtapositions in their paintings of 1907–8 (figs.13, 14) emerged, alongside the devices of *passage* and inconsistent lighting, as a means of calling attention to the conventionality of painting. As their awareness of the linguistic character of this conventionality grew, the different views of their pictures' subjects that were simultaneously visible took on a more diagrammatic appearance. For both painters, this was part of that process of giving greater prominence to a scaffolding grid, with the associated shift from iconic to symbolic signs traced earlier, and such perspectival juxtapositions were only briefly a preoccupation in their own right. For other Cubists, however, as well as sympathetic critics, the device became a cardinal feature of the style, and the difference between conception and perception a keystone of Cubist aesthetics.

It was first codified, once again, by Metzinger. In his article of the autumn of 1910 he discussed the 'free [and] mobile perspective' of Picasso, and Braque's 'clever mixing ... of the successive and the simultaneous' in terms of Bergson's notion of duration; the following year his painting *Tea-time (Le Goûter) (Woman with Teaspoon)* (fig.39) at the Salon d'Automne was a demonstration exercise in the distinction between idea and sensation. In French, 'goûter' means not only 'tea-time' but also 'to taste', and, as Christopher Green notes, in Metzinger's picture the suggestion of the

39
Jean Metzinger

Tea-time (Le Goûter) (Woman with Teaspoon) 1911

Oil on wood
75.5 × 69.5
(29¾ × 27¾)
Philadelphia Museum of Art. The Louise and Walter Arensburg Collection

senses in a state of activation – the naked young woman, her fingers touching the saucer, about to sip from the spoon – is acute. Yet the woman's sensations are known, not felt, by the spectator, and the difference between the two is underscored both by the diagrammatic juxtaposition of two views of the cup and saucer, and by the rather pedantic geometrification of her face, arms and torso.

The distinction was one seized upon and elaborated by critics, for by late 1911 Cubism was notorious enough to be the object of widespread debate. On the one hand many newspaper critics, succumbing to mounting nationalist hysteria in the wake of the second Moroccan crisis, condemned it as offensive and anti-French, some even equating it with the subversiveness of anarchism. On the other, young writers rallied to its cause in the little

magazines, concerned perhaps as much to raise their own profiles as to defend Cubist paintings, offering interpretations of Cubism that represented their own response to the heightened mood of nationalism and the aesthetic positions that mediated it. This debate produced a 'Cubism' that was a critical construct, only rarely anchored to the visual by discussion of particular paintings, but underpinned by reference to philosophical ideas or systems, and articulating more concerns than aesthetic ones alone. Thus in early 1912 the young critic Olivier Hourcade saw the Cubists' use of perspectival juxtapositions in their paintings as embodying a distinction between the essence and the appearance of the objects they represented, as precedent for which he cited Arthur Schopenhauer and Immanuel Kant. That his argument both rested on a misunderstanding of Kant's philosophy and explained nothing about actual Cubist paintings mattered little; it offered an intellectually substantial rationale for Cubism – which Hourcade then recruited for his own variant of nationalism, arguing that Cubist paintings revealed the essence of a race and a locality, and were thus part of the cultural patrimony of France.

Hourcade was soon followed by others. In March 1912 Jacques Rivière also discerned in the multiple perspective schemas of Cubism a distinction between the transitory appearance of objects and their essence; he harnessed this, however, to a classical aesthetic of stability and equilibrium, in whose terms he ridiculed the 'mad cacophony' of Cubist works. Like Hourcade he

made no reference to specific paintings – and an intellectual coherence for whose lack he castigated the Cubists was won at the expense of the ambiguities and contradictions that made their work so fruitful. The result was a reductive interpretation that betrayed a certain disdain for painters and their craft, and whose ideological grounding is underscored by his championing of André Lhôte, the most traditionalist of Cubist painters. Contrasting with the cold steel of Rivière's logic was the shotgun style of Maurice Raynal's critical début in the summer of 1912. Drawing, yet again, on purportedly Kantian distinctions between essence and appearance – in his expression, conception and vision – Raynal offered a wide range of additional references, from mathematics and contemporary scientific discourse to the philosophy of George Berkeley and the painting of Giotto, in support of an understanding of Cubism as an art of conception, and

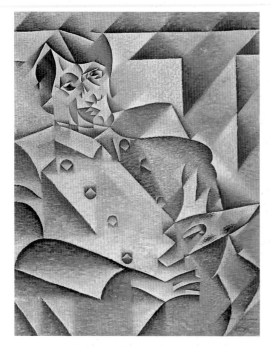

quoted approvingly Kant's dictum that the beautiful must be a 'finality without any purpose'.

This argument for what he called 'pure' painting, Raynal elaborated in his contribution to the *Golden Section* collection of critical writings that autumn; as we have seen, that essay was significant for its stress upon tradition and in its partisanship towards the aestheticism of gallery Cubism, which he saw as representative of such 'purity'. It was significant too in a third respect, namely its championing of an artist who in the absence of Picasso and Braque was, though a recent entrant to Cubism's lists, the leading representative of gallery Cubism in the Golden Section salon. Juan Gris had made his salon début in the Indépendants earlier that year, with a startlingly accomplished *Portrait of Pablo Picasso* (fig.40), the fellow-countryman whose painterly innovations he had been observing and absorbing from the proximity of an adjacent studio in the Bateau-Lavoir since 1906. Initially a cartoonist working for satirical magazines such as *L'Assiette au Beurre*, he had begun to paint in 1910, deploying the graphic flair and visual economy characteristic of the illustrator in paintings that, in their severely geometricised compositions, emphasised the conceptual aspect of the gallery Cubist conceits of scaffolding grid and juxtaposed viewpoints. If at first these qualities seem to have set limits on his achievement – the reticulations and complications of the *Portrait of Pablo Picasso* are perhaps too stylised and formulaic – they were soon tempered with a wit and a visual inventiveness that also owed much to his earlier

40
Juan Gris

Portrait of Pablo Picasso 1912

Oil on canvas
74.1 × 93
(29¼ × 36¾)
The Art Institute of Chicago. Gift of Leigh B. Block

41
Juan Gris

Man in a Café 1912

Oil on canvas
127.6 × 88.3
(50¼ × 34¾)
Philadelphia Museum of Art. The Louise and Walter Arensberg Collection

career. Thus *Man in a Café* of 1912 (fig.41), one of his entries in the Golden Section salon, at once deflated the bombast of Metzinger's *Tea-time* with humour, and dazzlingly elaborated upon its display of juxtaposed viewpoints, setting its top-hatted subject into impatient movement – his appearance and gestures inferred by the spectator in piecing together his face, cravat, hand and hat from the jigsaw of profiles depicted, and in making sense of their relation. Conception is the key to inferences such as this, as Raynal emphasised. 'We never, in fact, see an object in all its dimensions at once', he argued. 'Therefore what has to be done is to fill in

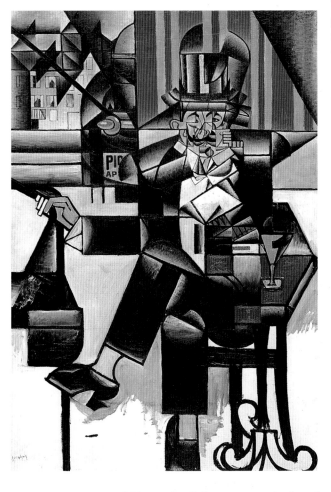

the gap in our seeing. Conception gives us the means. Conception makes us aware of objects that we would not be able to see ... and so, if the painter succeeds in rendering the object in all its dimensions, he achieves a work of method which is of a higher order than one painted according to the visual dimensions only.'

Gris was, for Raynal, 'the fiercest of the purists' in the Golden Section salon. His intellectual approach to painting was ideally suited to the role in which he found himself from late 1912, of mediator between salon and gallery Cubism, taking over from Metzinger the codifying and disseminating of the pictorial principles that were implicit in the latter – now, as previously noted, in the ascendant – and elaborating over the next few years a variant of Cubism that was both supremely individual and profoundly influential on other members of the movement. He remained close to Picasso and Braque, however, and his work of the two years before the war in particular continued to track theirs, taking some of its points of departure from their exploration of the linguistic character of pictorial representation. While the artists and critics of the Puteaux circle were comparing notes, sharing enthusiasms and contesting the terms in which their new paintings were to be understood, these two were pursuing that exploration with a single-mindedness that, by mid-1911, brought them close to submerging their individual artistic identities in the shared painterly style of hermetic, or analytic, Cubism, abandoning for several months even the signature of their respective

paintings in an apparent effort to establish an anonymous art. This effort had been one component of the aestheticism of the poet Mallarmé who, in his celebration of the 'incantatory power' of words had envisaged his self-effacement while they took the initiative, as he wrote, 'mobilised by the collision of their inequalities, kindling reciprocal reflections like the flashes of fire between precious stones'. But such self-effacement seems uncharacteristic of Picasso especially, for whom the display of his creative individualism was, as the *Demoiselles* project indicated, of fundamental importance. It is a measure of the profound significance that the Cubist adventure with Braque held for him that he should have allowed its imperatives to push that individualism, however temporarily, into second place.

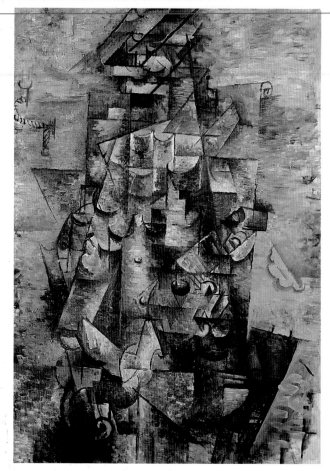

One moment of this adventure in particular — three weeks of working almost side by side in Céret, in the south of France, in August 1911 — resulted in a series of paintings in which it is indeed difficult to tell the Braques from the Picassos. Among them are the *Man with a Guitar* by the former and the *Accordionist* by the latter (figs. 42, 43). Although there are some differences between these two pictures — Braque's greater commitment to an overall low-relief space and his thicker handling of paint, as against Picasso's enjoyment of abrupt spatial discontinuities and his deftly-created play of overlapping transparent planes, for example — the remarkable similarities are just as significant. Each takes further than ever before the reduction of representational means to a minimum of signs, moving yet more radically than in the previous year away from resemblance (in semiotic terms, iconicity) in the creation of a lexicon of graphic marks and painterly motifs whose representational meaning is primarily dependent on relations of difference and position within the picture as a whole (in semiotic terms, symbolic signs) — in each case, the play of diagonals and triangles against a rectilinear grid. Yet both artists rely, crucially, on isolated iconic details — a loop of curtain rope, the fretboard of a guitar, the bellows of an accordion — as clues, or cues, to the reading of their paintings. Here the juxtaposition

42
Georges Braque

Man with a Guitar 1911

Oil on canvas
116.2 × 80.9
(45¾ × 31⅞)
The Museum of Modern
Art, New York. Acquired
through the Lillie
P. Bliss Bequest

43
Pablo Picasso

The Accordionist 1911

Oil on canvas
130.2 × 89.5
(51¼ × 35⅛)
Solomon R.
Guggenheim Museum,
New York

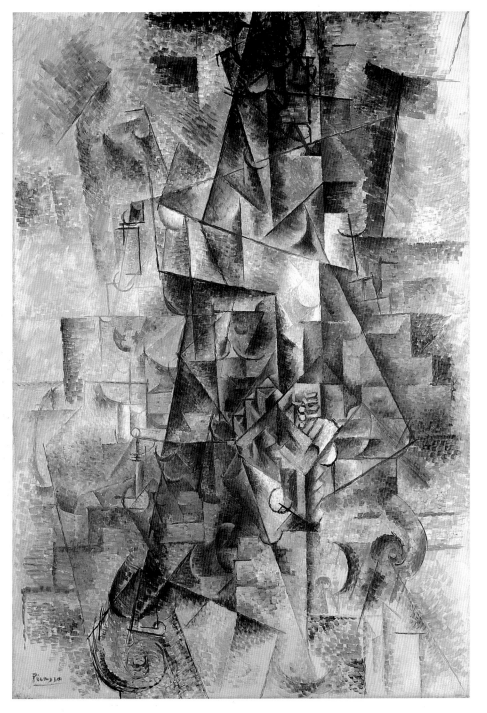

of perspective schemas plays a key role, at once revealing the conventional character of pictorial perspective itself and giving the painter greater freedom to position these details without regard to the demands of illusionistic coherence. Thus in both paintings, the spiral shapes lower left and right, denoting two chair-arm scrolls each pictured from a different angle, are enough, in combination with their positioning, to suggest the chair in which the musician sits, and also function as units in a system of differences between circles and straight lines in which the former stand variously for sleeve cuffs, collars, eyelids, soundholes and so on. Yet in each painting there is also a surfeit of illusionistic space; Picasso in particular plays with the devices of illusionism in a way that, if it kindles reciprocal reflections between them in the spirit of Mallarmé, still threatens his picture with illegibility.

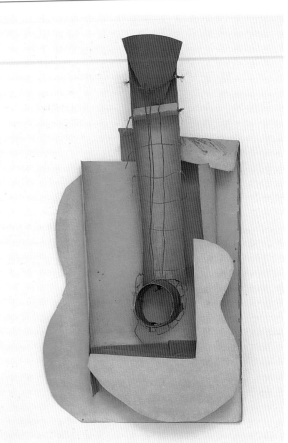

Picasso found a way beyond this tension between symbolic and iconic signs for spatial depth through a second encounter with African culture the following year, which was as important for him as that which had contributed so much to *Les Demoiselles d'Avignon*. In the summer of 1912 he bought, in Marseilles, a Grebo mask from west Africa (fig.45). As Kahnweiler was the first to observe, this mask 'bore testimony to the conception ... that art aims at the creation of signs. The human face "seen" or rather "read" does not coincide at all with the details of the sign, which details, moreover, would have no significance if isolated ... The epidermis of the face that is seen exists only in the consciousness of the spectator, who "imagines", who creates the volume of this face *in front of* the plane surface of the mask, at the ends of the eye-cylinders, which thus become eyes seen as hollows.' Picasso, thus recognising in this mask the rudiments of a non-iconic system for representing space, adopted it in his little cardboard *Guitar* of October 1912 (fig.44), in which, as Yve-Alain Bois argues, 'a sound hole protrudes and the virtual outer surface of the instrument is engendered non-mimetically by a network of contextual oppositions' – in other words, of symbolic signs.

If this analysis tends to overstate the abruptness and completeness of the transition from iconic to symbolic signs – resemblance plays a large part, after all, in our reading of the *Guitar* – it helps us to understand, and locate

to that autumn of 1912, the end of the hermetic, or analytic, phase of gallery Cubism during the course of which that shift was explored and its implications assimilated. And it also helps us to distinguish from it the next stage of Picasso and Braque's Cubism, in which this lexicon of Cubist signs provided the point of departure for each painting, rather than its destination. What has become known as 'synthetic' Cubism began with their invention and manipulation of *papier-collé* (pasted paper). This medium enabled them to transfer to two dimensions the system of non-illusionistic signs for spatial depth, surface and transparency, which the cardboard *Guitar* had first posited in the three dimensions of sculpture. As we shall see in the next chapter, however, there was more at issue in *papier-collé* than such formal concerns alone.

Picasso and Braque were not unique, within the Cubist movement, in pursuing their explorations in relative isolation from the talking-shop of the Puteaux circle. Robert and Sonia Delaunay began to measure their distance from that collective from the beginning of 1912, working independently on

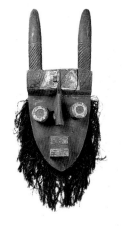

44
Pablo Picasso

Maquette for *Guitar*
1912

Construction of
cardboard, string and
wire (restored)
65.1 × 33 × 19
(25¾ × 13 × 7½)
The Museum of Modern
Art, New York. Gift of
the Artist

45
Grebo mask, west
Africa

Musée Picasso, Paris

pictorial concerns whose starting points were very different from those of gallery Cubism, yet which paralleled in key respects its 'linguistic' explorations. Both the differences and the similarities were summarised in the term 'simultaneity' and the meanings that this held for them. As I have said, Robert's picture of the Eiffel Tower at the 1911 Indépendants brought together his enthusiasm for the experiences of modern city life, and a painterly engagement with questions of the perception of deep space and its representation, which he shared, as he felt, with Cézanne and Rousseau. While these concerns were also evident in the other two cityscapes that he exhibited in room 41, they did not constitute the ambitious statement clearly presented by the *Tower*; yet it was from these, rather than the latter, that he developed – initially alone, but subsequently in partnership with Sonia – a distinctive, radical and influential approach to the pictorial representation of modernity.

The City No.2 (fig.46), probably painted early in 1911, was one of an irregular series of compositions begun in 1909 and based on a view taken from a picture postcard: the Eiffel Tower seen from the top of the Arc de Triomphe (fig.47). The subject afforded the same experience of plunging perspective as before, but with greater emphasis on the foreground buildings; here, Delaunay has exaggerated the view down on to these and elaborated on the conceit of the picture as a window, with the effect of enhancing its viewers' awareness of the picture surface as well as of their own subjectivity. Crucial in both respects is his use of a screen of neo-Impressionist brushstrokes that is suggestive at once of reflections on the windowpane and of aerial perspective breaking up the pattern of rooftops. Recognising the potential of this device, Delaunay repeated it in his next

works in this series, and in *Window on the City No. 3* (fig.48), painted in December 1911, he established with it the means to a radically different approach to the representation of simultaneity. In this work the screen of brushstrokes, building upon the pattern of light and shade created by the roofscape into a consistently diagonal checkerboard, extends to cover almost the entire picture surface, and overlays a larger checkerboard of squares originating from the same features. The resulting complex grid, if more formulaic in appearance than that in the work of Picasso and Braque

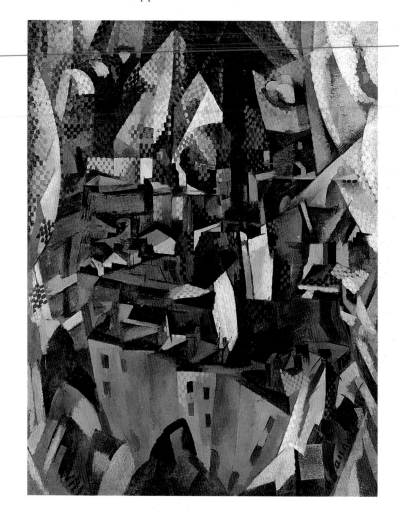

(though perhaps comparable in this quality to the latter's *Mandora*, fig.27), serves a similar purpose in both formal and 'linguistic' terms, tying the illusion of depth to the picture surface, and shifting the burden of representation from iconic to symbolic signs – from an image anchored in illusion to one whose meaning is dependent on the disposition of forms in the grid.

Once again however, as in 1909, it was Delaunay's commitment to questions of perception and modernity that distinguished his researches,

and their outcome, from the conceptual and formal preoccupations of gallery Cubism. In contrast to the paintings of Picasso and Braque at this time, colour plays an important role in *Window on the City No.3*. Although derived from the complementary pairings of sunlight and shade of which the Impressionists made so much, its colour relationships are more arbitrary than these, less anchored in imitation of nature, animating the surface pattern and, by the contrast of warm and cool colours, creating spatial recession independently of perspective. In his paintings of the following months Delaunay enhanced these qualities, taking the window/picture metaphor to the verge of abstraction in a series of over a dozen works made in the summer of 1912. *Windows Open Simultaneously (First part, Third Motif)* (fig.49) is one of them. Dispensing with the screen of neo-Impressionist brushstrokes – perhaps recognising its superfluity, given the constructive potential of the device of a colour grid – Delaunay orchestrates a range of spectral colours around the spatial recession from the foreground orange curtains to the background blue sky and the green profile of the tower. As in the hermetic paintings of Picasso and Braque, the representational legibility of the image is secured by the vestigial iconic character of these motifs. But unlike their exploration and celebration of the linguistic magic of painting for its own sake – or perhaps for its suggestion of a reality beyond appearance – Delaunay's bracketing of his complex and fragmented representation of the cityscape between the external limit of the picture frame/window and the internal limit of the distant tower posits an equivalence between the experience of deciphering the painting and the active, constructive nature of visual perception that life in a modern city entails.

In his works of this period Delaunay thus began to replace what Virginia Spate has termed the 'enumerative' simultaneity of his previous paintings – the multiplication and juxtaposition of views of the Eiffel Tower, for instance – with a 'perceptual' simultaneity engendered in the viewer's

46
Robert Delaunay

The City No.2 1911

Oil on canvas
146 × 114
(57½ × 45)
Mnam/Cci/Centre
Georges Pompidou,
Paris

47
Postcard of view from
Arc de Triomphe to
Eiffel Tower, owned by
Robert Delaunay,
*c.*1911

48
Robert Delaunay

*Window on the City
No.3* 1911

Oil on canvas
113.7 × 130.8
(44¾ × 51½)
The Solomon R.
Guggenheim Museum,
New York

49
Robert Delaunay

*Windows Open
Simultaneously (First
Part, Third Motif)* 1912

Oil on canvas
45.7 × 37.5
(18 × 14¾)
Tate Gallery

reading of its non-imitative signs. The development was supported by research into colour theory, in particular the writings of nineteenth-century scientist Eugène Chevreul, whose 'law of simultaneous contrast of colours' described the mutual enhancement of luminosity obtained when complementary colours are placed together. During the summer of 1912 Robert and Sonia, working closely together, fashioned an aesthetic upon this new realisation of the constructive potential of colour that was anchored in perceptual reality yet had metaphysical overtones. 'Without visual sensibility [there is] no light or movement', Robert declared in notes for an essay on 'Light', that summer; 'Light in nature creates the movement of colours. The movement is given by the unequal relations of contrast between colours that make up reality. When this reality is endowed with

50
Sonia Delaunay

Simultaneous Contrasts
1912

Oil on canvas
45.5 × 55
(18 × 21¾)
Collections
Mnam/Cci/Centre
Georges Pompidou,
Paris

depth (we see as far as the stars) it becomes *Rhythmic Simultaneity.*' It appears to have been Sonia who first realised in paint the implication of such an idea: if light itself is what is to be represented, and this with colour, painting it was tantamount to non-representation. The series of *Simultaneous Contrasts* that she painted alongside Robert that summer (fig.50) are anchored to representation, like his *Windows*, by vestigial iconic signs of the tower, but in replacing the window curtains with the sun and its halo, she critically loosened their grip, placing her painting on the threshold of abstraction.

In the following year she crossed that threshold, and at the same time offered yet another interpretation of 'simultaneity'. At the end of 1912 she and Robert were introduced by Apollinaire to a young poet, Blaise

51
Sonia Delaunay and Blaise Cendrars

Prose on the Trans-Siberian and of Little Jehanne of France
1913

Paper
195.6 × 35.6
(77 × 14)
Tate Gallery

Cendrars, whose enthusiasm for the 'modernolatry' and 'simultaneity' of city life matched theirs. During the first months of 1913 he wrote a long poem entitled *Prose on the Trans-Siberian and of Little Jehanne of France* about the memories, reflections and fantasies that pass through the mind of a young poet on a railway journey across Russia with an even younger French prostitute. It ends with their arrival in Paris, which Cendrars hymns as the hub of the world and of his own life. He and Sonia agreed that she should illustrate it, and that they should publish it; the result was a vertical paper panel two metres long that could be folded concertina fashion (fig.51). Cendrars' text runs the entire length of the right side, in twelve typefaces of different colours, while Sonia's visual accompaniment appears on the left, at times filling gaps left by the poem's unconventional layout. A syncopated rhythm of arcs, angles and vibrant colours, it counterpoints and complements the text, presenting, as the authors explained, a 'simultaneous contrast' such that the poem can be seen, at once, as a whole and as a sequential set of images.

Although they only managed to make 62 copies of the poem, Sonia and Cendrars had planned to publish 150 – it amused them that unfolded, these could extend to the top of the Eiffel Tower, which was both the poem's closing image and the emblem of a 'simultaneity' whose many dimensions it encapsulated more succinctly, and yet comprehensively, than any other product of that period.

4

HIGH AND LOW

Soon after marrying Robert Delaunay in 1910, Sonia Terk all but gave up
painting for two years. Although trained as a painter in academies in
Germany and Paris, and with a solo exhibition already behind her (in 1908
she showed works in a Fauvist, Gauguinesque style in a Left Bank gallery),
she turned instead to the design and making of objects of decorative art in
a number of media: embroidery, interior furnishing fabrics, book-covers,
clothes. The immediate reason for this change was her pregnancy and early
motherhood – the couple's son Charles was born in 1911 – which, it is
reasonable to assume, made more difficult the single-minded concentration
required by painting. But the fact that she had already made an embroidery
work soon after their relationship began in 1909 indicates that there were
other factors involved. As we shall see, these were significant for key aspects
of their art and that of the Cubist movement.

 One was the issue of gender. As noted in chapter one, the regressive
character of the social relations of sexuality that was a feature of the early
twentieth-century artistic avant-gardes meant that women were excluded
from participation as equals; the only available roles for them, with rare
exceptions, were those of muse, mother or manager of their men's careers.
Sonia was one of the exceptions, but she too felt the pressure to conform.
'From the day we started living together', she later recalled, 'I played second
fiddle', and she never exhibited her paintings alone again until after Robert's
death. The responsibilities of motherhood were also extended, at the time,
to the making of decorative art. In response both to the perceived threats

52
Robert Delaunay
The Cardiff Team 1913
Oil on canvas
195.5 × 132
(77 × 52)
Stedelijk Van
Abbemuseum,
Eindhoven

posed to the patriarchal order by the rise of feminism and the 'new woman', and to national security by France's declining birthrate, great emphasis was placed by men, in all arenas of public debate, on the domestic role of women. Decorative arts organisations campaigned through the 1890s for a return to the *ancien régime*'s tradition of aristocratic women as makers of luxury crafts, reinforcing assumptions that such skills were part of the expected accomplishments of young ladies. That Robert's mother was, around 1909, turning her own accomplishments in this area to financial advantage, designing floral embroidery motifs for sale, may have contributed to Sonia's turn to decorative work.

Such a turn was also in keeping, however, with a strong current of populism that was a feature of the cultural politics of that *avant-guerre*. Following the collapse of the Bloc des Gauches in 1905–6, middle-class anxieties over working-class unrest resulted in, among other things, efforts to democratise art, and widen access to it, by encouraging the manufacture and consumption of decorative arts, especially those rooted in traditional, provincial ways of life. As one of the leading promoters of such efforts, Roger Marx, declared in 1909, decorative art 'cannot be limited to a single class, for it belongs to all without distinction of rank or fortune: it is the art of the hearth and the garden city … of the precious jewel and peasant embroidery; it is also the art of the soil, the race and the nation'. Of the Delaunays, Robert in particular shared this populism, though not, initially,

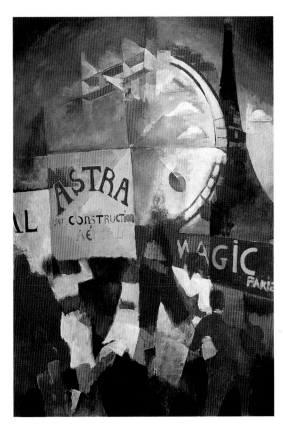

its associated enthusiasm for decorative arts. Rather, his unorthodox art training – he spent two years as a theatre decorator's apprentice in the working-class Belleville district of Paris – led him to identify with popular painting traditions, those of, as he put it, 'fairground and barbershop painters', which he saw as 'the unaffected and direct expression of those artisans'. A close friend of Henri Rousseau in the last years of the latter's life, he saw him as 'the genius, the precious flower' of this culture. (This and the above phrases are from a book on Rousseau that he began after *Le Douanier*'s death in 1910 but never finished.)

In keeping with this populism, Robert and Sonia regarded the general public – the crowds of the unjuried Salon des Indépendants, which was the only salon in which they showed – as the audience for their painting that mattered most. Robert worried endlessly about the accessibility of their experiments for this audience: 'As for our work', he wrote to Kandinsky in April 1912, 'I think … the public has made an

effort to get used to it … for [that public] these are, for the moment, unintelligible realities. I am sure, moreover, that this is my own fault. The primitive stiffness of the system is still for the public a stumbling-block in the way of its enjoyment'. They held back more experimental paintings such as *Windows Open Simultaneously* and *Simultaneous Contrasts*, therefore, from the Indépendants, exhibiting these only in gallery shows on the European avant-garde circuit. For the Salon, they painted huge works on deliberately popular, modern subjects, applying with moderation and legibility the devices and pictorial schemas of colour construction first elaborated in the experimental works. Examples are Robert's *The Cardiff Team*, exhibited in the Indépendants of 1913, and Sonia's *Bal Bullier* of the same year (figs.52, 53), paintings on the popular and modern themes of team sport and dance-hall respectively. They were followed in 1914 by Robert's *Homage to Blériot*, and Sonia's *Electric Prisms*, celebrations of aviation and electric lighting; as we have seen, Robert was working on *Political Drama* (fig.1) when war intervened. There is little doubt that they failed in this populist effort, since it appears from the responses of newspaper critics – who spoke for their readerships as much as to them – that these paintings met with as

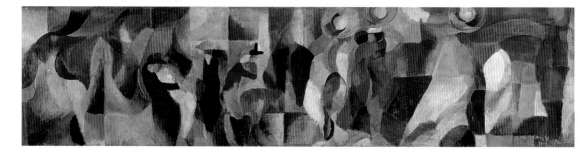

much public ridicule as those of other Cubists, but their intention to bring avant-gardist experimentation within reach of a modern mass audience is significant in itself.

Once again it was Sonia who found a more fruitful way to pursue this aim. If her decorative art and design work was gendered in origin and character, and populist in intention, it was also, increasingly, a product of her interest in applying the pictorial vocabulary that she and Robert were evolving to commercial ends. Robert's *The Cardiff Team* – its principal subject taken from a newspaper photograph of a rugby match – had incorporated the imagery of billboards, those already ubiquitous instruments of modern consumerism. It was but a short step from there to designing the advertisements themselves in projects such as posters for Dubonnet and other consumer products – thus from an embrace of commodified popular culture to participation in its production, and the implicit collapse of the distinction between that culture and Modernist art. Unsolicited by the manufacturers, the posters never made it to the hoardings, but these projects were the starting points for a post-war design career that Sonia Delaunay sustained for over fifty years.

Others within the Cubist movement were more ambivalent about Modernism's relation to both popular culture and the decorative arts. In their manifesto *On Cubism* published in the autumn of 1912, Gleizes and Metzinger, self-appointed spokespersons for the Puteaux group, claimed an unashamedly elitist role for the avant-garde artist. 'Let the artist deepen his mission more than he broadens it', they urged; 'Let the forms which he discerns and the symbols in which he incorporates their qualities be sufficiently remote from the imagination of the crowd to prevent the truth which they convey from assuming a general character'. Correspondingly, they dismissed decorative art as 'the antithesis of the picture'. Yet at the very moment of *On Cubism's* publication, some of their pictures at the Salon d'Automne were decorating the walls of a suite of furnished domestic interiors that was one of the most ambitious collective ventures of the Cubist movement. Orchestrated by André Mare, the project that came later to be known as the *Cubist House* had involved the participation of most of the members of the Puteaux circle, including Léger, the Duchamp brothers and Laurencin. Comprising an entrance porch, hall, living room and

bedroom, the ensemble was, for visitors to that year's salon, as unmissable a feature as had been the room of Cubist paintings the previous year, and gained the group greater notoriety than ever; two weeks after the salon opened, Roger Allard noted that the *Cubist House* had already received more insults than a Cubist painting (fig.54).

In one sense the project was a direct response to the call for a revival of decorative art mentioned earlier – not so much out of populism, however, as out of nationalism. Campaigners for that revival had expressed alarm at France's declining international competitiveness in an industry where it once reigned supreme, calling for an international exhibition to be held in 1915, as a means of regaining that pre-eminence. Sculptor Raymond Duchamp-Villon, one of the main contributors to the *Cubist House*, saw the risks: 'An initiative of this kind is a real contest in which the supremacy of artistic taste is at stake', he wrote shortly before the house project had been decided upon; 'we shall have to be ready to defend our once unassailable reputation'. André Mare thus gave clear instructions to his co-participants to 'make above all something very *French*, to remain within tradition'. The objects that resulted, though varied, shared for the most part the characteristics of that provincial classicism that Roger Marx and others had sought to encourage: bright colours, simple lines, a lack of artifice.

The project was also a response to a less explicit aspect of the decorative arts campaign. If foreign – in particular, German – competition was perceived to be threatening the reputation of French craftsmen, the entry of

women into traditionally male trades was threatening their wage rates and even their jobs. For both reasons these industries were – ironically – seen as a field too important to be left, after all, to women. Although circumstances were shortly to change again (as wartime mobilisation and its consequences once more drew women into the workforce), there was briefly an effort to re-masculinise decorative art. In this effort, art nouveau, the style that had dominated the previous decade, was rejected, and its curvilinear ornamentation criticised for its unbridled excess and overt sensuality, both, by implication, feminine. By contrast, the features that characterised the contents of the *Cubist House* – simplicity, severity, vigour – were seen not only as classical but as masculine as well. Given this context, the project can plausibly be interpreted, as art historian Nancy Troy suggests, as an effort to redefine decorative art itself, and the domestic interior in particular, as appropriate sites for men's artistic activity – though one perhaps vitiated by the participation of Marie Laurencin, whose four painted roundels of female heads in the living room presided like muses over the ensemble.

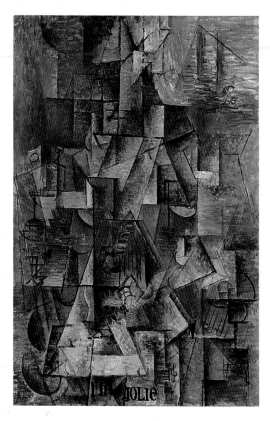

In one crucial respect the *Cubist House* stood in implicit opposition, however, to the decorative arts campaign. For all the provinciality of their stylistic references, its creators (with the possible exception of Duchamp-Villon) were little interested in populist gestures. The work they designed for it was not inexpensive everyday ware suitable for mass production, but luxury ware involving intricate ornamentation and expensive materials such as exotic woods, for the comfortable middle class, to whom it sold well: many of the components of the ensemble had been purchased before the salon opened, by the couturier Poiret among others.

The rejection, implicit in the *Cubist House*, of efforts towards the industrialisation of art and the democratisation of beauty was not only a refusal of the populist appeal, however; it also amounted to an acknowledgement of the pressures of debate within the Puteaux circle from 1912. As the ascendancy of gallery Cubism was consolidated in this milieu, the elitism of the group's collective venture marked the force of the aestheticist critique of the attempt to democratise art, to efface the distinctions between Modernist and popular cultural practices. Such distinctions were crucial to them, if the former were not to be overwhelmed by, and subsumed in, the latter. Yet if the populism of decorative art was a threat to their autonomy, modern urban popular culture – the rising tide of a commercialised, mass-produced, enticing yet

disposable visual culture of the everyday – was for some a challenge, as well as an inspiration.

Picasso's enjoyment of popular entertainment is well known, his visits to the circus and the cinema featuring prominently in accounts of his carefree early years in Montmartre. This enjoyment was complemented by, or found representation in, an increasing engagement with the vernacular that was registered in the paintings he and Braque made, as a kind of counterpoint to the developing hermeticism of their analytic Cubist style. Kahnweiler recalled that the two artists liked to 'play the worker' when they called at his house for their regular stipend, dressing in mechanics' blue overalls, doffing their caps and calling him 'boss'. Braque came from a family of house painters, and from 1911 some of the tricks of this trade, such as simulated woodgrain and stencilled lettering, appeared in their work. In the winter of 1911–12 Picasso added the words *MA JOLIE* (my pretty) at the bottom of a half-length portrait of his new girlfriend (fig.55). Not only functioning as a title within the work itself – and thus an ironic acknowledgement of how unflattering this almost illegible painting was – the words were also the opening of a popular song then on everyone's lips. From early in 1912 he began to use Ripolin enamel house paint in place of his usual oils in some pictures, and that May took the radical step of gluing on to a canvas a fragment of oilcloth with an industrially printed chair-caning pattern, thereby inventing – or at least, for the first time appropriating for art practice – the technique of collage (fig.56).

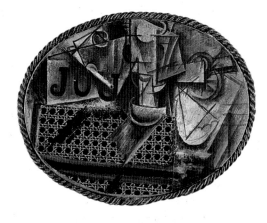

55
Pablo Picasso

'Ma Jolie' (Woman with Zither or Guitar) 1911–12

Oil on canvas
100 × 65.4
(39½ × 25¾)
The Museum of Modern Art, New York. Acquired through the Lillie P. Bliss Bequest

56
Pablo Picasso

Still Life with Chair Caning 1912

Oil, oilcloth and pasted paper on canvas edged with rope
27 × 35
(10¾ × 13¾)
Musée Picasso, Paris

These features were not simply gestures of affection for popular culture or of identification with its predominantly working-class consumers, however. In the post-Bloc des Gauches, post-Moroccan crisis moment, when (as noted earlier) the communities of the artistic avant-garde and those of the working class were each turned in on themselves and engaged in the consolidation of an autonomous identity, such cross-identification was not a readily available position. In this context, the titling of *Ma Jolie* amounted to a register of the gulf that separated the private concerns of Picasso's art from everyday popular culture. But it was more than this. In the years of the close collaboration between Braque and Picasso, supported by a small circle of friends and patrons, their art practice had a subcultural character, and as in all subcultures, their borrowings of motifs, materials and behaviour from outside of it were reworked, acquiring private connotations as part of a process of distinction and positioning in relation to mainstream culture. In this reworking, the mechanics' overalls, house painters' tricks, Ripolin enamel and collaged oilcloth stood for a rejection

of artistic orthodoxies – of an outmoded 'bohemian' sartorial style, of the *belle peinture* associated with vacuous academic and/or fashionable art, of the notion of art as dependent on craft skills and on what was known as the *patte*, or paw, of the painter.

The pictorial borrowings were also instrumental to their explorations of the linguistic basis of pictorial convention, their elaboration of a system of signs that were less securely anchored in resemblance, and in particular less tied to spatial illusionism. Simulated woodgrain was a means of signifying a wooden object or surface without positioning it spatially; stencilled letters were by definition flat, and could be read either as on the picture surface or as within the pictorial space. In September 1912 Braque took this simulation one stage further, gluing a piece of wallpaper, industrially printed with imitation woodgrain, on to a sheet of paper and drawing over both; the result, *Fruit Dish and Glass* (fig.57), was the first *papier-collé* (pasted paper). It was in Picasso's hands, however, that the multiple levels of its potential as a medium were realised. For where Braque saw the illusionistic and compositional implications of the technique, Picasso understood how *papier-collé* could both translate the discoveries of his cardboard *Guitar* (fig.44) into two dimensions, signifying transparency and spatial depth non-illusionistically, and meet the challenge posed by the vitality and ephemerality of popular culture. Abandoning painting almost entirely for several months from the autumn of 1912, he plunged into a period of hectic experimentation with the new medium.

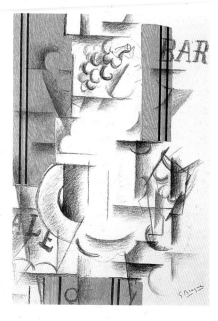

57
Georges Braque
Fruit Dish and Glass
1912

Charcoal and printed paper on paper
62 × 44.5
(24½ × 17½)
Private Collection

Glass and Bottle of Suze (fig.58) is one of the first *papiers-collés* that Picasso made, and one of a series using little more than newspaper and charcoal drawing, whose making coincided with the outbreak of a conflict in the Balkans that threatened to drag all Europe into war. The newspapers were full of this, and in this series Picasso appears to have made deliberate and repeated use of headline references to its daily developments. Here, the newspaper cuttings that cover half of the picture surface, encircling a blue paper oval (standing non-illusionistically for a round café table-top seen at an angle) consist of reports from the battlefront and an account of a demonstration against the war held in Paris by the Socialists. These cuttings form the formal ground, and their contents the figurative background of events, for a private life symbolised not only by the objects on the café table – a white paper (i.e. clear) bottle of the popular aperitif, Suze, and a glass, the former casting a black paper shadow – but also by the esoteric manner

in which these are depicted, their inaccessibility to anyone outside of the subcultural group. Foregrounded by their position in the centre of the image, the contours of these objects are defined by a further cutting; this is taken not from war reports, however, but from the serialised romantic novel of the day. The combination of visual and verbal signs thus reads as a juxtaposition of – indeed, a dislocation between – that discourse of public

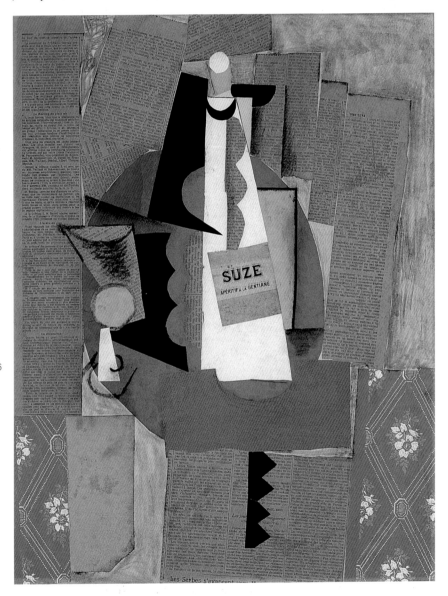

58
Pablo Picasso

Glass and Bottle of
Suze 1912

Pasted papers,
gouache and charcoal
65.4 × 50.2
(25¾ × 19¾)
Washington University
Gallery of Art, St Louis.
University Purchase,
Kende Sale Fund, 1946

events and this private world of creative play and affective experience; a dislocation that symbolised that existing more generally, as I have noted, between the artistic avant-gardes and working-class politics.

This semiotic play around the border between public and private cultures and experiences characterised not only the Balkan war series but much of Picasso's experimentation with *papier-collé* through 1913. They reveal his

delight in the way the medium could, in his hands, interweave with his arcane formal explorations a multiplicity of reference – via scraps of newspaper, wallpaper, cigarette packets and other printed ephemera – to everyday life in all its variety, banality and often, squalor. Close reading of these *papiers-collés* yields accounts of murders, suicides and burglaries alongside witty and often scabrous word- and image-play. Common to many of them, and increasingly to those of early 1914, was reference to what separated these interwoven orders of experience, art and the everyday, namely the conventions – of materials, context and language – of art itself. Juxtaposing drawing styles, playing with references to the frame – as in the witty *Pipe and Sheet of Music* (fig.59) – and, in the spring of 1914, opening them into the three-dimensional space of the viewer, as in the Tate Gallery's little *Still Life* (fig.4), Picasso called into question those conventions, and through them the status of an art dependent on them, replacing this with an idea of art as imagination. Pierre Daix's observation about the first *papiers-collés* is applicable to these works: 'Never before had the painter so completely destroyed the mystery of his work, never before did he present himself to the scrutiny of the spectator, not only without the tricks of the trade, but using means that are within everyone's grasp. And never before had a painter asserted his power as a creator, as a poet in the strongest sense of the word.'

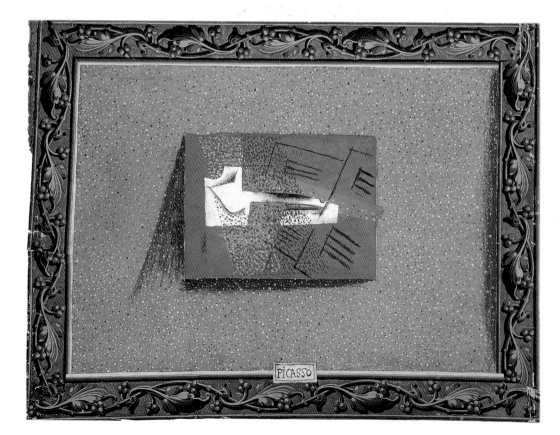

Conclusion: After Cubism

'I never saw them again', said Picasso of Braque and Derain, in that remark quoted at the beginning of this book, after he had said goodbye to them at Avignon station in August 1914; which was to say that with the outbreak of war and the general mobilisation of French military forces, the companionships of the previous decade had irretrievably ended, and the Cubist adventure was over. This was both true and false.

It was false, because Cubism as a movement, though severely depleted by the mobilisation, continued as a force to be reckoned with in the Parisian avant-garde through the war years and after. Picasso himself continued to extend, in three dimensions as well as two, the range and complexity of his pictorial ideas; Gris and Metzinger evolved, and codified, a version of Cubism that was a point of reference in aesthetic debate for the next several years. New and innovative artists – Henri Laurens, Jacques Lipchitz, Diego Rivera, among others – adopted and extended the style and its pictorial implications. Indeed, as Christopher Green argues, post-1914 Cubism was in some respects more important to the history of Modernism than pre-1914. But this is another story. The war was a watershed in the histories of its combatant nations, dividing all aspects of their cultural, as well as political and social, life into 'before' and 'after' August 1914, and although many of the components of the wartime and post-war conjunctures were present in that of the *avant-guerre*, the new circumstances threw fresh divisions into relief, and old ones into the shade. The fault-line that ran through Cubism – and the many milieux of the Parisian avant-garde as a whole – was no longer

59
Pablo Picasso

Pipe and Sheet of Music 1914

Pasted papers, oil and charcoal
51.4 × 66.6
(20½ × 26½)
The Museum of Fine Arts, Houston. Gift of Mr and Mrs Maurice McAshan

between salon and gallery orientations, but between combatants and non-combatants in a conflict that, as Kenneth Silver has shown, had its cultural as well as military dimension. As nationalism secured the terms in which Modernism, and Cubism its main exemplar, were to be assessed, a mood of retrenchment and reaction came to dominate cultural discourse in Paris.

But that Cubism was over, and not just different, was also in a profound sense true. This was not only because some of its original members had already drifted away, and its collective momentum – Allard's 'Cubist empire' – had in consequence already been dissipated, but more importantly because the assumptions that had governed its pictorial inquiries, whether those of salon or gallery Cubism, were being called into question by artists

across Europe. In place of an exploration of the linguistic and conceptual character of pictorial conventions of representation – whether in the interests of reflection on the experience of urban modernity, or of critical resistance to the seductions of its popular culture – a generation of artists who had themselves been formed by that exploration were making more radical assertions either of the autonomy, or the social instrumentality, of art.

Within a year of each other, on the eve of the war, painters across Europe – Piet Mondrian in the Netherlands, Wassily Kandinsky in Germany, Kasimir Malevich in Russia, among others – were, like Sonia and Robert Delaunay, crossing the threshold of abstraction, some placing painting in

the service of a more thorough-going idealism than any Cubist had proposed, others insisting on its inescapable perceptual and material basis. In cities where revolution or the possibility of it had politicised avant-garde debate, art's role in building as well as representing a new world was on the agenda. When Vladimir Tatlin returned to Moscow in 1914 after seeing the constructions of Picasso and Braque in Paris, the relief constructions he then made (fig.60) were both indebted to theirs and a radical departure from them. Stepping beyond not only the constraints of two dimensions and orthodox materials, like Picasso's *Still-Life* (fig.4), but also beyond the conventions of a fictive space that continued to separate that work *as* still-life, like an invisible picture-frame or pedestal, from the real world of the viewer, these reliefs stood for nothing but themselves. As 'real materials in real space', in Tatlin's own words, they were an implicit rejection of the very conception of art on which Picasso's work rested. In the same year, Marcel Duchamp took to their logical conclusion the assertions of the conceptual basis of art that had been made, repeated and elaborated in discussions at his house in Puteaux. In nominating an everyday object, a bottle-rack, as a

work of art without materially altering it in any way – the first of a series of *Readymades* (fig.61) – he was not only, like Picasso, rejecting the idea of art as craft but also, unlike him, proposing art as idea as art in itself.

Yet if gestures such as these called Cubism into question, they were made in a conjuncture of war and revolution, a moment of profound threat to the social order of which Modernism was an integral part. When that conjuncture ended, and with it the exchange between revolutionary politics and the potentially revolutionary aesthetics of Cubism, the achievements of the latter were fundamental in fashioning, in all the arts, a lexicon for a Modernism that would represent and mediate the social life of the twentieth century. In film and theatre, in music and the written word, Cubism's insistence on the role of representation in the production of reality has been a cardinal point of reference, indeed, at times, of principle. This has been so above all, however, in painting and sculpture – though Cubism's influence on the latter came largely from an unexpected quarter. There were few sculptors even associated with Cubism before 1914, and only one of them, Raymond Duchamp-Villon, was a member of the Puteaux circle. His experiments in sculptural form, tragically abbreviated by his death in the war, related only loosely to the concerns of his painter friends, and were closer in spirit to those of the Futurist Umberto Boccioni, also killed at the front; had these two lived, Modernist sculpture would have been all the richer. But most of the carving- and modelling-based conventions and techniques with which they worked had already been swept aside by Picasso's iconoclasm. His relief constructions, growing out of his

experimentation with pictorial space, opened up a rich vein of possibilities for innovation in sculpture, which, from Laurens and Lipchitz, through Naum Gabo and Louise Nevelson, David Smith and Anthony Caro has been deeply and productively worked. The technique of collage that Picasso and Braque introduced has had an even wider progeny, its juxtapositions of second-hand images and materials enabling (among other things) explorations of – and assaults on – the boundaries and status of fine art practice along a broad front, from Dada through Pop art to Postmodernism. And both the constructions and collage technique, together with other features of Cubist style, have continued down the century to inform the work of the most innovative architects, from Le Corbusier to contemporaries such as Daniel Liebeskind and Frank Gehry.

The bracketing together of these three names underlines the fact that, as with all such seminal movements, different artists, groupings, even generations, have appropriated and interpreted Cubism in different ways, some of which have enriched its meanings, while others have narrowed them to suit the requirements of the cultural mainstream. In recent years, the enthusiasms and achievements of Cubists other than Picasso and Braque have come increasingly to be acknowledged and the complexity of its history recognised. It is important to hold on to these insights if the historical significance and the lessons of Cubism are to be fully understood.

PHOTOGRAPHIC CREDITS

Courtesy Annely Juda Fine Art (60); © 1998 The Art Institute of Chicago (40); Baltimore Museum of Art (8); Bibliothèque Nationale de France (2); Bridgeman Art Library (16, 61); British Architectural Library, RIBA: photo A.C. Cooper (Colour) Limited (11); Christie's Images (3); Haags Gemeentemuseum 1998 c/o Beeldecht Amstelveen (21, 37); Walter Klein, Düsseldorf (35); Kröller-Muller Museum, Otterlo (22); Kunstmuseum, Bern: Photo Peter Lauri (14); © 1981 The Metropolitan Museum of Art, New York (13); The Minneapolis Institute of Arts (24, 36); © Moderna Museet, SKM, Stockholm (26); Musée Barbier-Müller, Geneva: photo P.A. Ferrazzini (10); Museu de Arte de São Paulo Assis Chateaubriand: photo Luiz Hossaka (30); The Museum of Fine Arts, Houston (23; The Museum of Fine Arts, Houston: photo T.R. Du Brock (59); © 1998 The Museum of Modern Art, New York (5, 9, 42, 44, 54); National Gallery, London (6); © Board of Trustees, National Gallery of Art, Washington: photo Richard Carafelli (1); Offentliche Kunstsammlung Basel: photo Martin Bühler (18, 27); The Board of Trustees of the National Museums and Galleries on Merseyside (Walker Art Gallery) (25); Photothèque des collections du Mnam-Cci, Paris (34, 46, 50, 53); Photothèque des collections du Mnam-Cci, Paris: photo Philippe Migeat; Photothèque des collections du Mnam-Cci, Paris: photo Jean-Claude Planchet (32); Photothèque des Musées de le Ville de Paris: photo P. Perrain (7); Pushkin Museum (15); © RMN (17, 45); RMN: photo R.G. Ojeda (29, 56); Tate Gallery Photographic Department (4, 19, 28, 31, 49, 51); Philadelphia Museum of Art: photo Graydon Wood (39, 41); © The Solomon R. Guggenheim Foundation, New York: photo David Heald (43, 48); Stedelijk Van Abbemuseum, Eindhoven (52); Washington University of Art (58)

COPYRIGHT CREDITS

Every effort has been made to trace the copyright owners of works reproduced. The publishers apologise for any omissions that may inadvertently have been made.

Braque, Derain, Duchamp, Gleizes, Gris, Léger, Metzinger: © ADAGP, Paris and DACS, London 1998

Robert Delaunay, Sonia Delaunay: © L&M Services B.V. Amsterdam

Matisse: © Succession Henri Matisse/DACS 1998

Picasso: © Succession Picasso/DACS 1998

All other copyright works © The artist or estate of the artist

FURTHER READING

The art-historical literature on Cubism, as might be expected of such a pivotal style and movement, is extensive. Approaches to its interpretation, and the assessment of its significance, have varied over the course of the century, however. This introduction to Cubism is written from the perspective of a social history of art, with the intention of presenting a broad and historically informed understanding of the movement's development and achievements. A more extended presentation of it may be found in this author's *Cubism and the Politics of Modernism: Art and the Avant-Garde in Paris 1905–1914* (New Haven and London 1998). Several other authors are mentioned in the present text; their works, plus additional writings providing useful starting points for further reading on Cubism, are listed below.

Blau, Eve and Troy, Nancy J., *Architecture and Cubism*, Montreal, Cambridge, Mass., and London 1997

Bois, Yve-Alain, 'The Semiology of Cubism', in , William Rubin and Lynn Zelevansky (eds.), *Picasso and Braque: A Symposium*, New York 1992

Chave, Anna C., 'New Encounters with *Les Demoiselles d'Avignon*: Gender, Race, and the Origins of Cubism', *Art Bulletin*, vol.76, no.4, 1994, pp.596–611

Daix, Pierre and Rosselet, Joan, *Picasso: The Cubist Years 1907–1916*, London and New York 1979

Duncan, Carol, 'Virility and Domination in Early Twentieth-Century Vanguard Painting', in *The Aesthetics of Power*, Cambridge 1993

Golding, John, *Cubism: A History and an Analysis 1907–1914*, London 1959, 1968

Green, Christopher, *Cubism and its Enemies: Modern Movements and Reaction in French Art, 1916–1928*, New Haven and London 1987

Leighten, Patricia, 'Picasso's Collages and the Threat of War', *Art Bulletin*, vol.67, Dec. 1985, pp.653–72

Poggi, Christine, *In Defiance of Painting: Cubism, Futurism and the Invention of Collage*, New Haven and London 1992

Reff, Theodore, 'The Reaction against Fauvism: The Case of Braque', in William Rubin, and Lynn Zelevansky (eds.), *Picasso and Braque: A Symposium*, New York 1992

Robbins, Daniel, 'Jean Metzinger: At the Center of Cubism', in *Jean Metzinger in Retrospect*, exh. cat., University of Iowa Museum of Art, Iowa City 1985

Rosenblum, Robert, 'Picasso and the Typography of Cubism', in John Golding and Roland Penrose (eds.), *Picasso 1881–1973*, London 1973

Rubin, William, 'From Narrative to "Iconic" in Picasso: The Buried Allegory in *Bread and Fruitdish on a Table* and the Role of *Les Demoiselles d'Avignon*', *Art Bulletin*, vol.65, Dec. 1983, pp.615–49

Silver, Kenneth E., *Esprit de Corps: The Art of the Parisian Avant-Garde and the First World War, 1914–1925*, London 1989

Spate, Virginia, *Orphism: The Evolution of Non-Figurative Painting in Paris 1910–1914*, Oxford 1979

Troy, Nancy J., *Modernism and the Decorative Arts in France: Art Nouveau to Le Corbusier*, New Haven and London 1991

Weiss, Jeffrey, *The Popular Culture of Modern Art: Picasso, Duchamp and Avant-Gardism*, New Haven and London 1994

INDEX